PROUD TO BE A BAGGIE

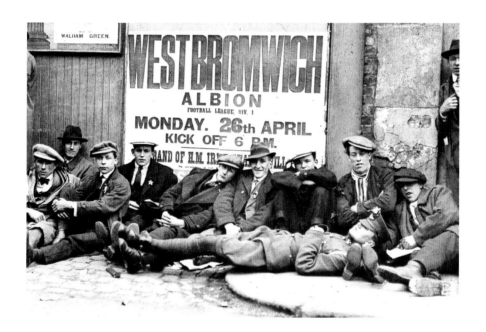

DEAN WALTON

AMBERLEY

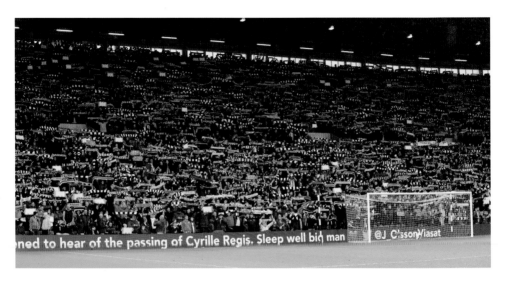

In memory of Cyrille Regis MBE
1958–2018

Cover photos, clockwise from top left:
Albion fan at the 1935 FA Cup final. (Getty Images)
Albion fans outside Wembley, 1970. (Trinity Mirror)
San Jose Earthquakes v WBA, 2011. (Dean Walton)
The Woodman Corner v Swansea, play-off semi-final, 1993. (Stuart Roy Clarke)

First published 2018

Amberley Publishing
The Hill, Stroud
Gloucestershire, GL5 4EP

www.amberley-books.com

Copyright © Dean Walton, 2018

The right of Dean Walton to be identified as the
Author of this work has been asserted in accordance
with the Copyrights, Designs and Patents Act 1988.

ISBN 978 1 4456 8127 6 (print)
ISBN 978 1 4456 8128 3 (ebook)

British Library Cataloguing in Publication Data.
A catalogue record for this book is available from the
British Library.

Origination by Amberley Publishing.
Printed in Great Britain.

CONTENTS

Foreword by Cyrille Regis MBE

My West Brom debut against Rotherham United on 31 August 1977 changed my life. It was the beginning of a love affair with the Albion fans, which I'm pleased to say continues to this day. That evening most of the crowd had probably never even heard of this raw black kid signed for £5,000 from non-League Hayes, yet here they were chanting 'Cyrille, Cyrille' when we were awarded a penalty. I couldn't believe that they were urging me to take it. We were winning 2-0 at the time and fortunately I blasted it into the Smethwick End net to put us three up. The Brummie Road End went mad and I went on to bag a fourth; it was a fantastic feeling.

It says a lot about the Albion fans. Work hard and they'll respect you for it. They are hard-working Black Country people who toil in factories and foundries. They understand effort, they have been brought up on a diet of attacking teams down the decades, they know what hard work is and want players wearing the navy blue-and-white stripes to try their hardest. I think they recognised that I worked my socks off and appreciated my efforts. Racism was rife at the time but the Albion fans welcomed Laurie, Brendon and I as their own and supported us through some difficult periods.

We had a fantastic team in the late '70s and early '80s – full of skill and flair. We came so close to winning all three major trophies: losing three semi-finals and finishing third in the top division. We even made the quarter-final of the UEFA Cup. I just wish that we could have rewarded those brilliant fans with some silverware.

Sadly, my time at the Baggies eventually came to an end and I moved on, initially to Coventry City (where I finally received an FA Cup winner's medal) and I also played for Albion's arch rivals Villa and Wolves. However, the Albion fans never held it against me. Whenever I played against West Brom with a different team I always got a terrific reception. One game that sums up my great relationship with those fans was in 1994 when I came on as a sub for Wolves at

The Hawthorns. It was like my debut all over again as I got cheered by both sets of fans. I was humbled by the level of affection shown by the Albion fans. The Baggies won 3-2, so I was on the losing side, but although you always want to win for the club you are playing for, even if it is against the team you support, on this occasion the result didn't matter to me. It was great to be back at The Hawthorns, and it was a touching moment for me to receive the applause of both sets of fans. Apparently I'm the only player wearing the gold and black ever to receive a standing ovation from the Albion supporters!

Since I hung up my boots I have continued to live in the area and I'm always meeting Albion fans and reminiscing about the 'good old days'. I've met Dean on numerous occasions and his passion for his beloved Baggies always shines through. This book is a trip down memory lane for what I consider to be the most dedicated, crazy, fun-loving and passionate fans in the world of football.

Cyrille Regis, December 2017

Early Years

Founded in 1878, West Bromwich Albion were one of the original twelve members of the Football League (formed in 1888). We first reached the FA Cup final in 1886 losing 2-0 to Blackburn Rovers after a replay. The following year we were in the final again, this time against Aston Villa and another 2-0 defeat. In 1888 it was third time lucky, beating Preston North End 2-1 at the Oval.

After losing two FA Cup semi-finals, we made it to our fourth final in 1892, once again against our old rivals Villa, and a brilliant performance saw us lift the trophy after beating them 3-0. Our next final came in 1895 when we lost 1-0 to Villa at Crystal Palace.

Albion moved from Stoney Lane to The Hawthorns in 1900 and reached the FA Cup semi-final in the first season, losing 4-0 to Tottenham Hotspur. Sadly our League form wasn't good and we suffered relegation in 1902 and 1904. Our Cup form was still good though, and in 1907 we lost 2-1 to Everton in the semi-final.

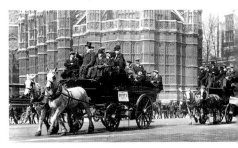

In 1911 we finally gained promotion back to Division One and in 1912 we were once again in the FA Cup final, this time losing to Second Division Barnsley in a replay.

The 1919/20 season turned out to be our finest, as Albion were named League Champions for the first and only time in the club's history. We followed this up with a Charity Shield victory, beating Spurs 2-0. We came close to another League title in 1925, finishing runners-up.

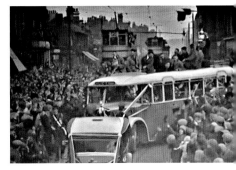

In 1927 we were relegated and spent four seasons in Division Two before an incredible 1930/31 season saw us not only gain promotion but win the FA Cup, beating Birmingham City 2-1 at Wembley. We lost 1-0 to Arsenal at Villa Park in the Charity Shield.

In 1935 we made it to Wembley for the second time in four years, but sadly lost 4-2 to Sheffield Wednesday. Two years later we appeared to be heading there again but unfortunately fell to Preston in the semi-final, losing 4-1 at Highbury. Disaster struck in the 1937/38 season when we suffered relegation. Then after just one season the Second World War broke out and League football was suspended until 1946. Promotion was secured in 1949 and we were back in Division One.

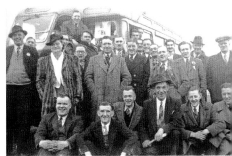

Top: Albion fans taking a tour of London before the 1912 FA Cup final against Barnsley at Crystal Palace.

Middle: The victorious team arrive back in West Bromwich with the FA Cup in 1931.

Bottom: A supporters trip from the Dunkirk Inn to Gateshead in 1949.

1950s

Albion remained in the First Division for the whole of the 1950s. In the 1952/53 season Ronnie Allen's goals helped secure a fourth-place finish. The following season was the most successful in the club's history: not only did we win the FA Cup, but we also finished runners-up to Wolves in the League – so close to the 'Double'. The Charity Shield was shared following a 4-4 draw at Molineux. We reverted to the lower reaches in the next few seasons. However, Wembley was in sight again in 1957, but we unluckily lost to Villa in the semi-final following a replay at St Andrew's. Back up to fourth in 1957/58, and we finished the decade in fifth place (1958/59).

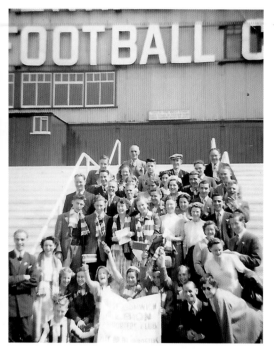

This page, left: Supporters Club members on the steps of White Hart Lane for the 3-1 defeat at Spurs. 25.08.51.

Below left: My mom (second from left) with her friends on the terraces at St James' Park, Newcastle, for the 2-0 victory over Gateshead. 06.02.52.

Below: Albion fans at Blackpool before our 2-0 defeat. 22.03.52.

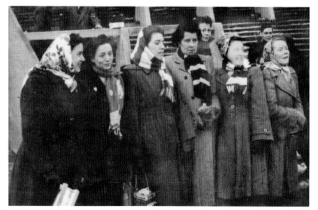

Welcomed to Deepdale by the Preston North End Supporters Club. 06.09.53

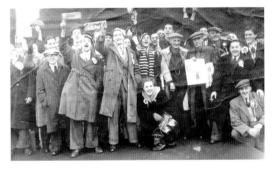

Lionel Whiteley (in scarf and cap) with fellow Baggies on their way to Newcastle in the '50s.

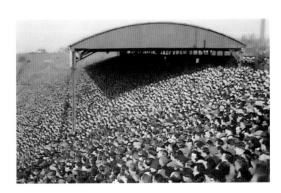

61,800 in The Hawthorns for the 3-2 FA Cup victory over Newcastle. 20.02.54.

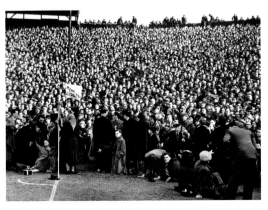

**Preston North End
Won 3-2
FA Cup Final
Att: 99,852
Wembley Stadium
1 May 1954**

Almost two decades and a world war had passed since Albion had last played under the twin towers. Now we were back and facing a good Preston team that included the legendary Tom Finney. Albion fans had been allocated a miserly 12,000 tickets and you had to send a postal order to be entered into a ticket lottery. Over 70,000 applied, leaving most loyal fans disappointed. In a thrilling final, the game swung both ways before Frank Griffin scored the winner with just three minutes remaining.

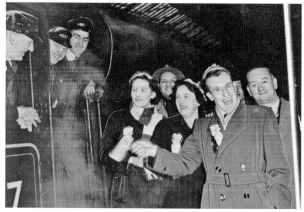

Above left: Lionel Whiteley all ready for Wembley.

Above right: Engine driver Wilf Rawlings greets June Carter and Winnie Jeffries as they board the train for London.

Below: My dad Harold Walton (with shield) and my mom Betty (immediately behind) on the way to Wembley. Also in the photo are Barbara Walton and 'Maltese' Tony Falzon.

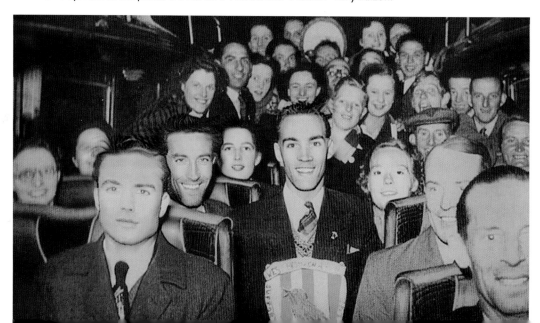

Right: The Supporters Club, including Ethel and Bill Mason, set off for Wembley.

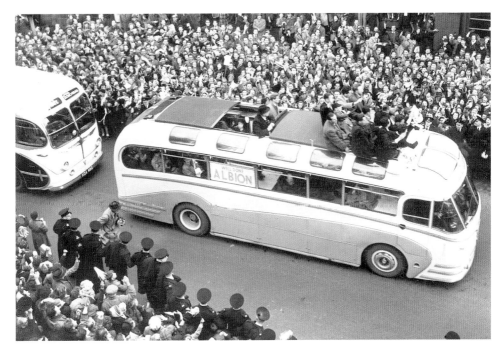

Above: The victorious team bring the cup back to West Bromwich.

Right: Injured goalkeeper Norman Heath visits the Oldbury Supporters Club.

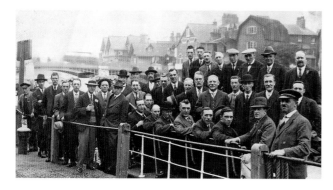

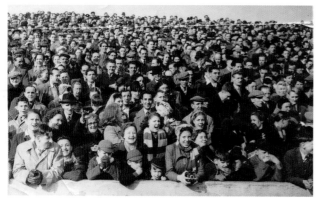

Top: Albion turnstile operators and checkers, 1950s away trip.

Middle: The Brummie Road End at The Hawthorns in the 1950s.

Bottom: The Handsworth side (now the East Stand) v Wolves, 20.08.55. A 1-1 draw in front of 45,306.

Opposite, top: The Brummie Road End in the 1960s.

Opposite, bottom left: Fans leave the ground on the Birmingham Road following our 2-2 draw with Sunderland. 25.02.67

Opposite, bottom right: An old view of the Halfords Lane stand.

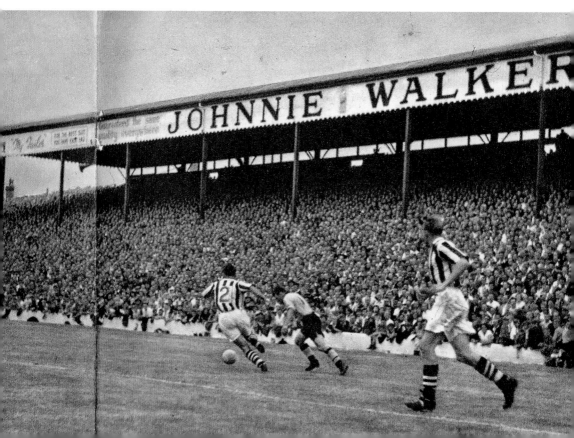

1960s

Another decade in the top flight. Albion began the 'swinging '60s' with a fourth-place finish. We then hovered around mid-table for the next nine seasons, but we certainly gave the cups a good go. In 1965/66 – our inaugural season in the League Cup – we beat West Ham over two legs, lifting the trophy at The Hawthorns. We looked to retain the League Cup at Wembley in 1967, but after being 2-0 up at half-time a disastrous second half saw Third Division QPR coming back to beat us 3-2. We were back at Wembley the following season and Jeff Astle's extra-time goal against Everton gave us the FA Cup for the first time in fourteen years. A nightmare took place in the Charity Shield at Maine Road when champions Man City thrashed us 6-1. We came so close to Cup glory again in 1969, making it to the semi-final at Hillsborough. Sadly Albion fan Allan Clarke's goal, with just three minutes remaining, sent Leicester to Wembley.

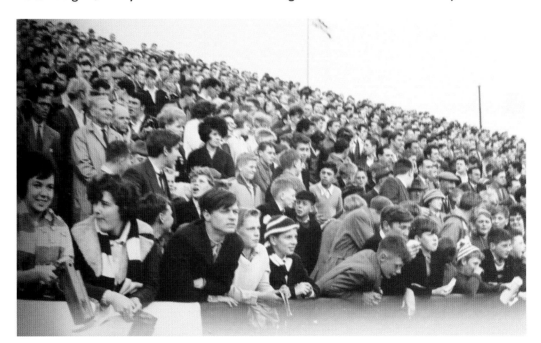

**West Ham United
Won 4-1 (5-3 agg.)
Football League Cup
Final Second Leg
Att: 32,013
The Hawthorns
23 March 1966**

A special night under the Hawthorns floodlights as we overturned a 2-1 first leg deficit to win the League Cup at the first time of entering. The West Ham trio of Moore, Hurst and Peters were just two months away from winning the World Cup with England, but on a cold night in West Bromwich they were no match for a rampant Baggies. Goals from Kaye, Brown, Clark and Williams destroyed the Hammers and our Welsh international skipper lifted the trophy from the director's box in the old Halfords Lane stand.

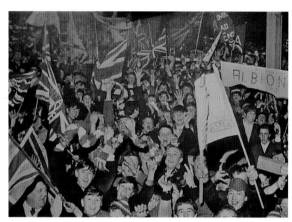

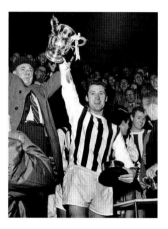

Above left: A jubilant Brummie Road End.

Above right: Captian Graham Williams lifts the League Cup.

Left: George and Mabel Dell with the League Cup. George gave a lifetime of service to the Albion, from programme seller to groundsman.

Below: Former player Reg 'Paddy' Ryan takes the League Cup to Hamstead Junior School.

Above left and right: Terry Wills in his 'Throstle's nest' and flying the flag on Albion's European trip to Utrecht, Holland. 02.11.66

Right: John Lloyd with his daughter Lorraine outside Wembley before the 1967 League Cup Final.

Below: Barry Swash, Graham Clifford, Alan Cox and David Thomas mix with other Baggies on the promenade at Blackpool before our 3-1 win. 06.05.67

**Birmingham City
Won 2-0
FA Cup Semi-Final
Att: 60,831
Villa Park
27 April 1968**

We made the short trip to Villa Park to see us take on our Second Division neighbours. The Blues put up a really good fight and could easily have got a better result, but goals from the deadly duo of Astle and Brown sent us to Wembley for the second year running.

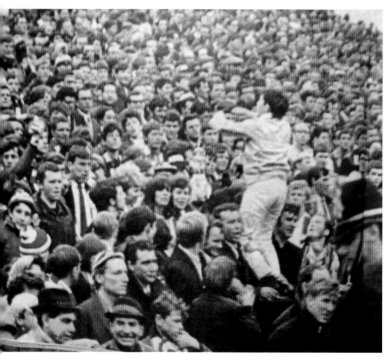

Left and below left: Albion fans in full voice in the Witton End at Villa Park.

Below right: The famous Albion 'Dolly Ladies'.

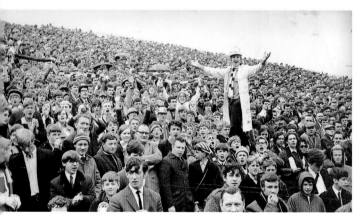

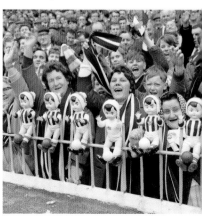

**Everton
Won 1-0
FA Cup Final
Att: 99,665
Wembley Stadium
18 May 1968**

Cup fever once again swept the Black Country. The Baggies were back at Wembley for the second year running. This time we received 12,000 tickets, but this was still nowhere near enough to satisfy the massive demand. Our opponents Everton had already beaten us twice in the League that season, including a 6-2 drubbing at The Hawthorns just two months earlier. The final certainly wasn't a classic and went into extra-time. Then Jeff Astle became the first player to score in every round when he unleashed a left-footer that flew past Gordon West. The King had done it; the Cup was coming back to West Bromwich.

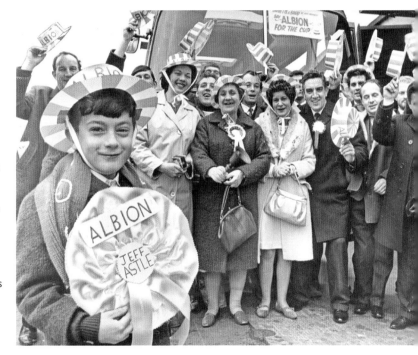

Right: Ten-year-old Ray Jackson and supporters from Barratts & Baird set off for Wembley.

Below left: Barry and Tony Matthews with Alan Brettell at New Street Station.

Below right: Hamstead lads (including Dave Rushton and Robert Fellows) arrive at Wembley Stadium.

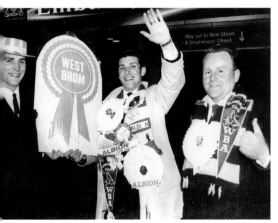

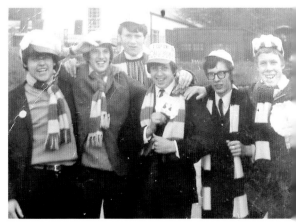

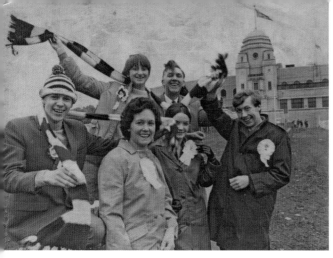

Early arrivals at Wembley: Great Barr Baggies Alan Moore, Sally Firkins, Janet Moore, Annette Joyce, Albert Firkins and Graham Firkins.

The 'Dolly Ladies' inside Wembley.

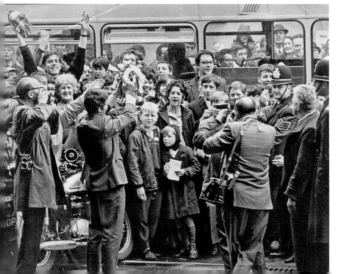

Captain Graham Williams returns with the FA Cup.

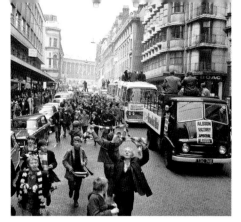

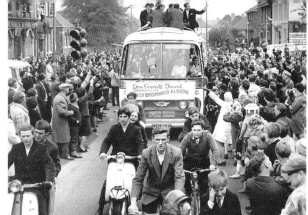

Above left: The players' coach leaves Birmingham city centre with a young Barry Swash running ahead.

Above right: The coach passes The New Inns pub in Handsworth.

Right: The victors return, passing The Barrell pub.

Below: A crowd of 250,000 in West Bromwich town centre with the Star & Garter pub on the right.

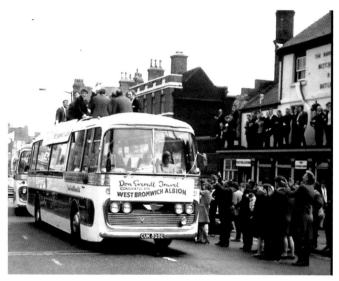

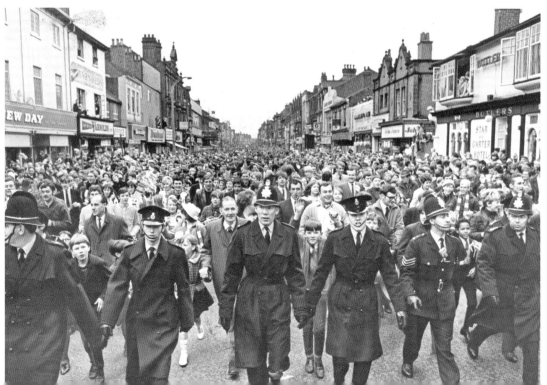

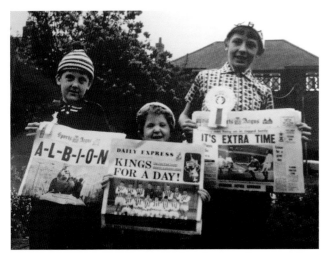

Top: Read all about it. David, Sharon and Graham Cartwright take in the news.

Middle: Alan Jones with his scarf from '68. They don't knit them like that anymore!

Bottom: George and Steve Battye board the plane with other Baggies for Bucharest in the European Cup Winners' Cup. 13.11.68

Opposite, top: Typical Smethwick End scene in the late 1960s.

Opposite, bottom and inset: FA Cup semi-final in 1969. Albion fans pack the Spion Kop at Hillsborough and witness a disappointing 1-0 defeat to Leicester.

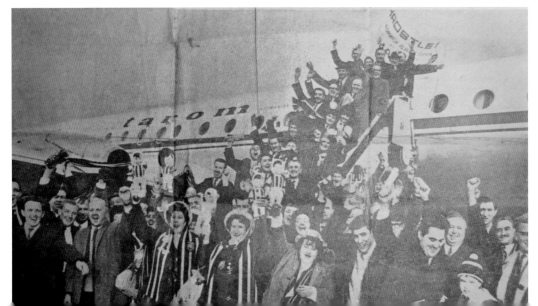

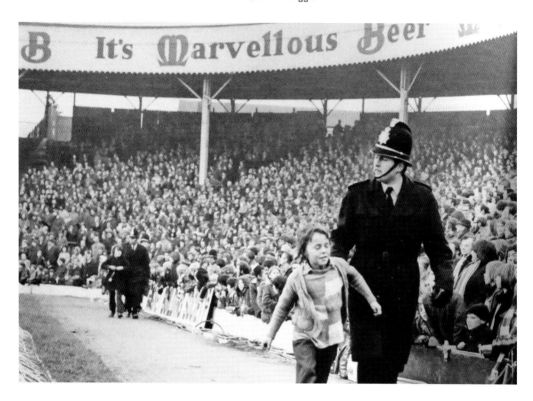

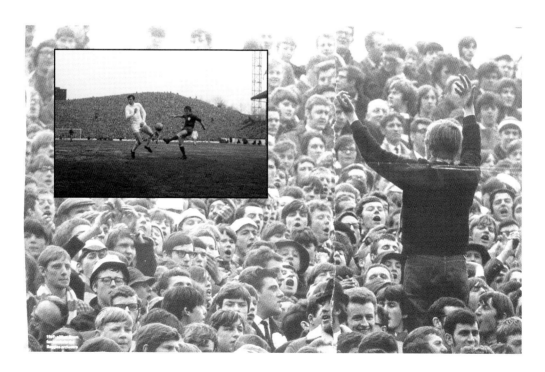

1970s

Just three months into the new decade and we were back at Wembley for the third time in four years! Unfortunately we lost 2-1 to Manchester City after extra-time in the League Cup final. We couldn't maintain our Cup form and struggled in the League. Don Howe's side suffered relegation at the end of the 1972/73 season for the first time since 1949. In our third season in the second tier, Johnny Giles came in as player-manager and following a memorable victory in our last game at Oldham, we were back in the big time for the 1976/77 season. A respectable seventh-place finish in our first campaign was bettered with a top six place in 1977/78. Ron Atkinson's team was really exciting to watch and a great cup run in 1978 took us to Highbury in the FA Cup semi-final, a nightmare for Albion fans as Ipswich beat us 3-1. 1978/79 was an amazing season and we looked to be heading for the title until the bad weather kicked in. We eventually lost out to Liverpool, then slipped into third place, losing to Nottingham Forest in the last game of the season. We also came close to UEFA Cup success, beating glamour side Valencia before succumbing to a sickening defeat to Red Star Belgrade in the quarter-final.

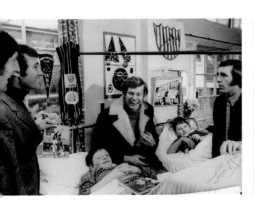
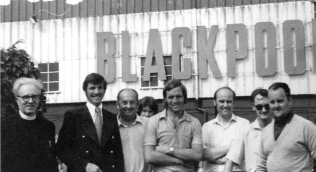
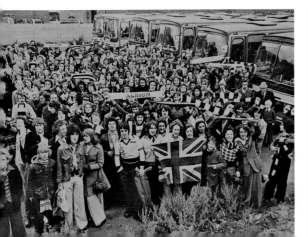
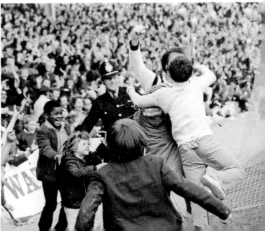

Manchester City
Lost 1-2
Football League Cup
 Final
Att: 97,963
Wembley Stadium
7 March 1970

This was becoming a habit! We were on our way to Wembley again for the third time in four seasons, this time to try and bring back the League Cup that we won in 1965. Heavy snow had fallen in the week leading up to the final and to make matters worse, the Horse of the Year show had been held at the stadium just a few days earlier – the famous Wembley turf was more like Greets Green rec! On to the game and The King out-jumped Joe Corrigan to head us into a first-half lead. As the lads tired, City equalised and forced the match into extra-time and duly grabbed the winner. Never mind, we thought; we'll be back again in the next year or so. Little did we know that it would be another twenty-three years until we returned to the Twin Towers.

Opposite, top left: Albion players Tony Brown, Graham Williams, Jim Cumbes and Jeff Astle visit twelve-year-old Kevin Candon in hospital.

Opposite, top right: Revd Brazier, Tony Matthews, Tony Salt, Alan Hartshorne and Alan Brettall with Jeff Astle outside Bloomfield Road, Blackpool, in 1970.

Opposite, bottom left: On the Throstle Club car park ready to board the Sealandair coaches for an away game in the '70s.

Opposite, bottom right: Watney Cup Final, 1971. The King equalised in the last minute.

Above right: Colin and Martin Lynes outside Wembley Stadium.

Right: Astle puts us 1-0 up.

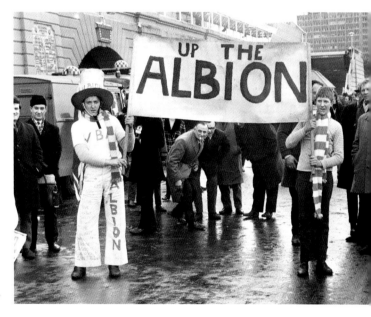

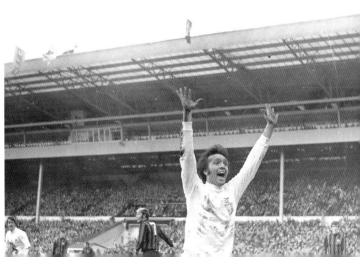

Oldham Athletic
Won 1-0
Division Two
Att: 22,356
Boundary Park
24 April 1976

Over 16,000 Albion fans turned the M6 blue, white, yellow and green as Johnny Giles's army transformed Boundary Park into The Hawthorns. With Bolton winning at half-time away at Charlton, the maths was simple: to secure promotion we HAD to win. The script was written for Albion legend Tony Brown. Bomber was born just down the road in Oldham Infirmary and he duly scored the winning goal to send us back to the top division. The pitch was soon filled with celebrating fans after the final whistle. A truly memorable day.

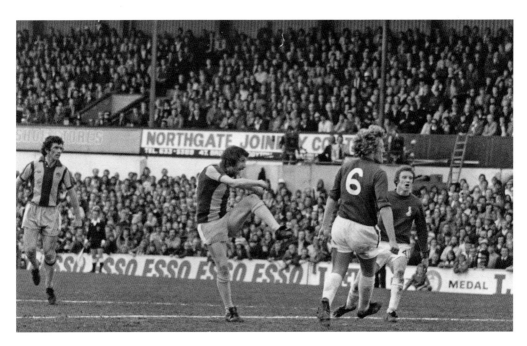

GOING UP!

Opposite, top: Albion fans pack the Chaddy Road End at Boundary Park.

Opposite, bottom: Oldham-born Tony 'Bomber' Brown scores the winning goal.

This page: We are going up! Albion fans fill the Oldham pitch to celebrate promotion back to Division One.

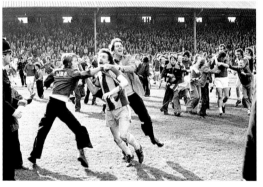

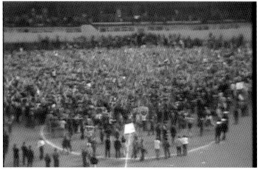

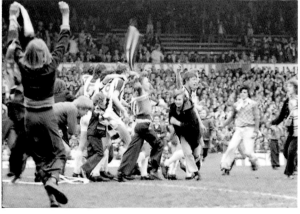

Top: Sixteen-year-old Chris Onyan in his usual '70s matchday attire.

Middle: A typical pitch invasion following an Albion goal at The Hawthorns.

Bottom left: Tony Matthews, Colin Mackenzie, Laurie Rampling, Ray Duffin and Alan Brettall at Stamford Bridge before Chelsea v Albion in 1976.

Bottom right: Rejoice! Another goal at the Brummie Road End.

Ipswich Town
Lost 1-3
FA Cup Semi-Final
Att: 50,922
Highbury
8 April 1978

The best and most exciting Albion team that we had seen for years headed for north London full of confidence. After despatching Blackpool, Manchester United, Derby County and Nottingham Forest we felt that nothing could stop us and Wembley beckoned. Unfortunately Ipswich, with Bobby Robson in charge, had other ideas. With a packed North Bank urging the Baggies on, everything went wrong: John Wile split his head open, Willie Johnston injured his shoulder and Mick Martin got sent off. Bomber's penalty gave us a glimmer of hope, but it was not to be and the Tractor Boys went on to beat Arsenal in the final.

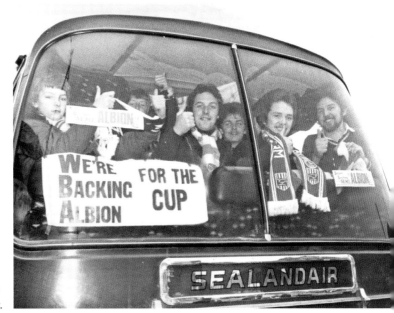

Right: The coaches leave The Hawthorns.

Below left and right: Albion fans in the North Bank at Highbury.

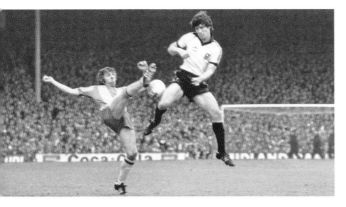

Valencia
Drew 1-1
UEFA Cup
Att: 47,746
Estadio Luis
 Casanova
22 November 1978

What a night! Valencia were one of the best teams in the world at the time, featuring World Cup stars Kempes and Bonhoff. We had a fantastic team ourselves and even though Bomber was out injured, Laurie Cunningham had the game of his life, and we held them to a 1-1 draw, setting us up nicely for the second leg.

On a freezing cold night at The Hawthorns, Bomber was back, scoring both goals in a memorable 2-0 win.

Left: Two members of the London Supporters Club, Mark Gardner and Rab Rogers, with Ron Atkinson, Colin Addison and Tony Matthews all set to fly to Spain.

Below left: Dean Walton, Nigel Bellmore, Tony Jones, Barry Swash and Kevin Pitt board the Dan Air flight to Valencia.

Below right: Albion fans at Luton Airport heading for Valencia.

UEFA CUP SUCCESS

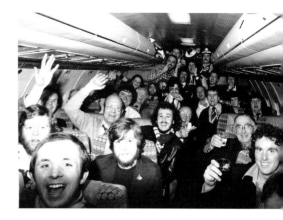

Top and middle right: On the Dan Air flight. We arrived at the stadium just in time for kick-off and then flew straight back after the game. Back at work the next morning!

Below right: Baggies in Benidorm before heading to Valencia.

Below left: Albion fans arrive back from our 2-0 victory in Braga, Portugal. 18.10.78

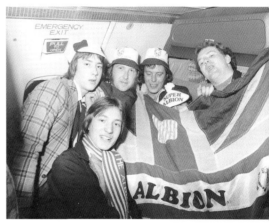

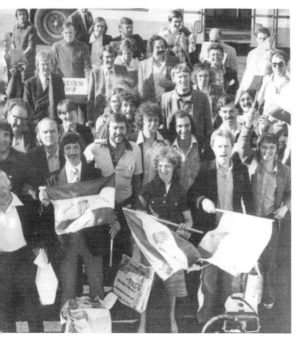

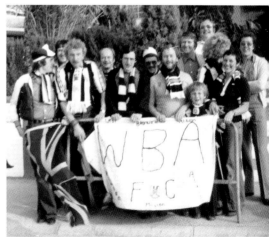

**Red Star Belgrade
Lost 0-1
UEFA Cup Quarter-
 Final First Leg
Att: 93,300
Marakana Stadium
7 March 1979**

A massive disappointment. Just when we sensed UEFA Cup glory, we lost the quarter-final in such unfortunate circumstances. There were two people killed inside the stadium prior to kick-off when rival supporters from the two Belgrade clubs clashed on the terraces. No Albion fans were involved. An enormous crowd of over 93,000 saw the Baggies go down 1-0. In the second leg, Cyrille Regis gave Albion the lead at a packed Hawthorns. However, Red Star agonisingly equalised late in the game, sending us out 2-1 on aggregate.

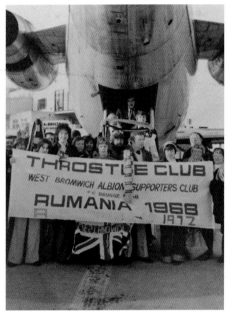

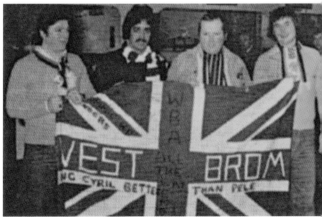

Above left: Albion supporters including Mick Corfield board the plane for Belgrade.

Top right and above right: Inside The Maracana, Belgrade.

Left: Franc Andrews before the home leg against Red Star.

Garth 'Mac' Maclean bags Laurie Cunningham's shirt following our 3-1 win against Stoke, 14.05.77. Mac later wore Laurie's shirt when working a summer season in Benidorm.

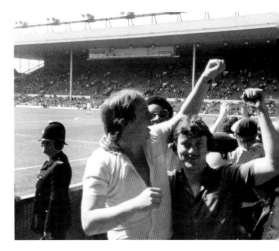

Members of the London branch on a regular trip to a home game in 1977.

Malcolm 'Sweat' Llewellyn and Mark Carter at Anfield before our 3-1 defeat to Liverpool. 25.08.79

Franc Andrews and Richard Fischer mix with locals in East Germany before our UEFA Cup game against Carl Zeiss Jena. 19.09.79

1980s

The 1980s began with a top-half First Division finish followed by an excellent fourth place in 1980/81. Our European campaign was short-lived as Grasshoppers of Zurich knocked us out in the first round. We looked to be heading for Wembley in the two Cup competitions in 1982, but managed to lose BOTH semi-finals. Losing to Spurs over two legs in the League Cup, we were then back at Highbury for the FA Cup semi-final where Second Division QPR beat us 1-0. Our First Division status came to an end in 1985/86 when our worst ever season in League football saw us finish rock bottom. For the rest of the decade we struggled in Division Two. Attendances were at an all-time low and the club was on its knees.

Left: RATS on tour: Brighton away, won 2-1. 20.08.80.

Below left: Albion fans in the away end at Southampton's old Dell ground before our 2-2 draw. 21.02.81

Below right: In the Kippax 'pen' at Maine Road for our 2-1 defeat to Manchester City. 14.03.81

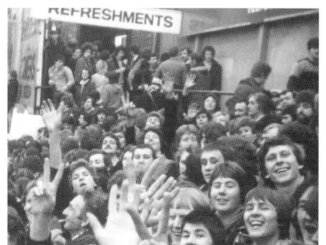

Grasshoppers of Zurich
Lost 0-1
UEFA Cup
Att: 8,101
Hardturm Stadium
16 September 1981

Albion fans had high hopes as we converged on the Swiss city of Zurich. We arrived by plane, car and coach and all gathered at the 'Grasshopper Bar' opposite the stadium. The game was a disappointment, succumbing to a 1-0 defeat, which was followed by a 3-1 defeat in the second leg at The Hawthorns. No more European trips for us that season.

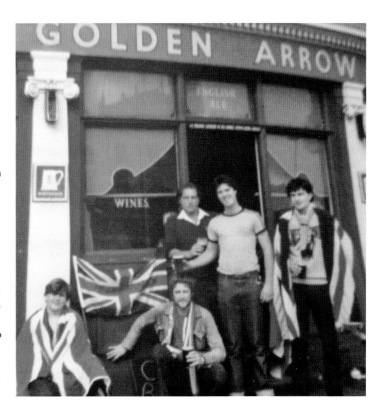

Right: In Dover on the way to Zurich: Albion fans including Nick Horton, John 'Sauce' Tkaczuk and Steve Knight.

Below left: Michael 'Silve' Silvester, John 'Skeeny' Skeen, Andy Payne, Dean Walton, Malcolm 'Sweat' Llewellyn, Dave 'Skin' Loats and Tony Jones on the steps of Luxembourg's national stadium on the long drive to Zurich.

Below right: In Zurich centre before the game.

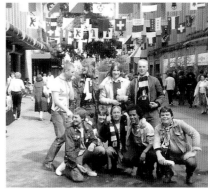

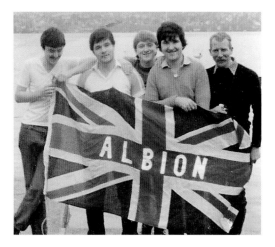

Above left: On the banks of Lake Zurich: Tony Littler, Steve Battye, Mark Martin, Malcolm Cope and Ian Smallman (who travelled to Zurich on his motorbike).

Above right: Stuart Brandwood, Tim Bayliss and Steve Duffy.

Middle: Sweat from Wednesbury and the Great Barr lads arrive in Zurich.

Below: In the Hardturm Stadium.

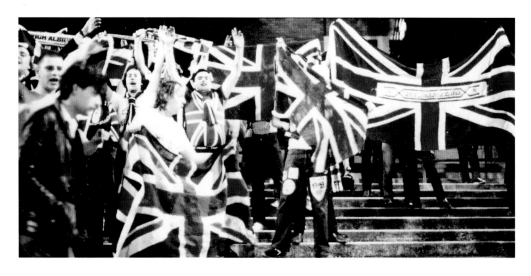

Another drunken European trip comes to an end: Sauce and his mates commiserate.

Queens Park Rangers
Lost 0-1
FA Cup Semi-Final
Att: 45,015
Highbury
3 April 1982

Agony at Highbury again. Another FA Cup semi, this time against Second Division QPR. Albion fans were given the Clock End on this occasion and despite giving the team tremendous support, Ronnie Allen's men never really got going and a lucky deflection off Clive Allen's knee sent the west London team to Wembley. A massively disappointing day.

Right: The RATS (Red Admiral Travel Section) on the way to Highbury.

Below: This time the Albion fans were allocated the Clock End at Highbury.

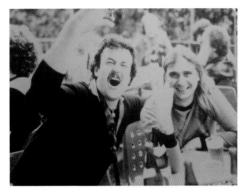

Two Albion stalwarts: The late Richie Brentnall and 'Long Haired' Mick Hamblett in Zurich 1981.

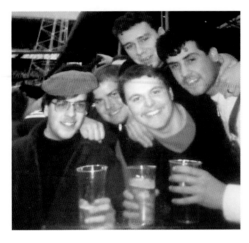

In White Hart Lane before the League Cup semi-final second leg: Gary Evans, Andrew 'Tats' Taylor, 'Timebomb' Tim Bayliss, Mark 'Snarka' Whitehouse and Keil Fieldhouse. 10.02.82

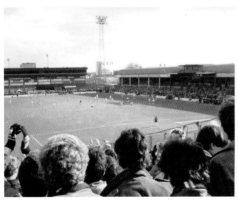

At Meadow Lane watching our 2-1 victory over Notts County. 15.03.82.

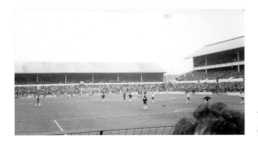

White Hart Lane watching us draw 1-1 with Spurs. 04.12.82.

**Ipswich Town
Division One
Portman Road
1980–86**

It all started on New Year's Day 1980. Several Albion fans from the Red Admiral pub in Great Barr headed straight to Ipswich from all-night parties in their pyjamas! As an alternative to the club's official HATS (Hawthorns Away Travel Section) the lads from the pub formed the RATS (Red Admiral Travel Section). Over the next few years Ipswich away became a pyjama-clad tradition and eventually turned into full fancy dress – the first football fans to do this, I believe.

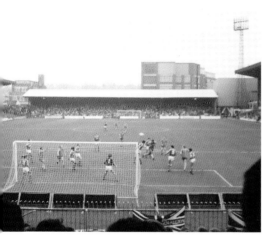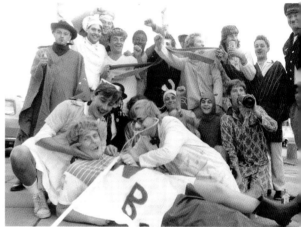

Above left: View from the away end at Portman Road.

Above right: Leaving the Scott Arms, Great Barr, for Ipswich. 20.10.84

Below: On the Red Admiral car park before getting into our removal van, bound for Ipswich. 22.03.86

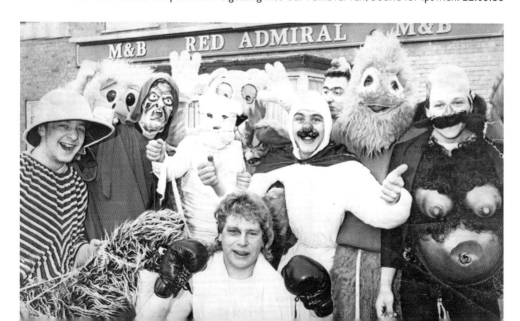

**Dumbarton
Lost 1-2
World Club
 Championship
Att: 745
Boghead Park
6 August 1988**

Pre-season 1988 and a few hundred Albion fans (including a Supporters Club coach) headed to Scotland to see the restaging of a game played in 1888 against a team called Renton (a defunct club that was close to Dumbarton). Albion were FA Cup winners in 1888 and Renton were the Scottish Cup winners (we lost 4-1). This time around we were a poor Second Division team and duly lost again, this time 2-1 to Dumbarton with the winning goal coming from their bald, fat, middle-aged coach, who came on as a substitute! More than half the crowd was made up of Albion fans.

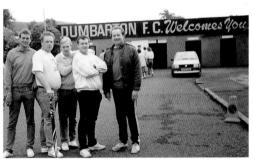

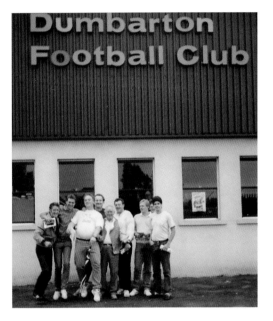

Above and left: Dean Walton, Michael Silvester, Chris Edwards, Dave Foxall and Neil Lewis arrive at Boghead Park.

Below: The long-since demolished Boghead Park, the setting for the World Club Championship!

Thirteen-year-old Nathan Reynolds from Bedworth before his mascot duties against Coventry City at Highfield Road. 27.04.85

Leicester City's old Filbert Street ground, this time watching our 2-1 defeat in front of just 11,960 fans. 22.09.85

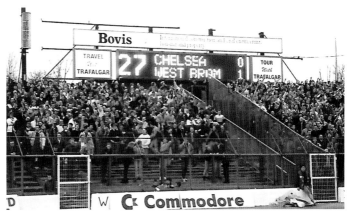

The old away end at Stamford Bridge. Sadly we couldn't hold on to the lead and the game against Chelsea ended 1-1. 31.12.89

**Hull City
Won 1-0
Division Two
Att: 5,217
Boothferry Park
13 May 1989**

Our first ever beachwear party, nothing at stake (we finished ninth) and just sheer lunacy as over a thousand Albion fans headed to Boothferry Park in Hawaiian shirts, Bermuda shorts and flip-flops; we even had lilos, beach balls, and buckets and spades. An amusing site as we entered the ground: piles of Cornflake boxes piled up outside the turnstiles, confiscated by the police for some strange reason! Kevin Bartlett got the winner on what was a fun-filled afternoon. We stayed in the ground after the final whistle and a bemused Brian Talbot finally led the players back out of the dressing room and across the pitch. Colin West threw his boots into the crowd and the rest politely applauded, looking totally baffled!

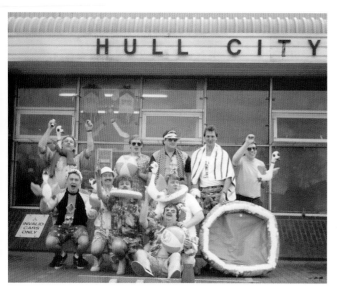

WHERE'S THE BEACH?

Below left: Mooner's crew on the way to Hull.

Below right: Albion fans enter Boothferry Park ready to party.

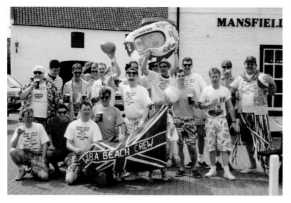

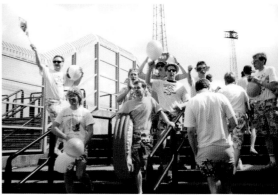

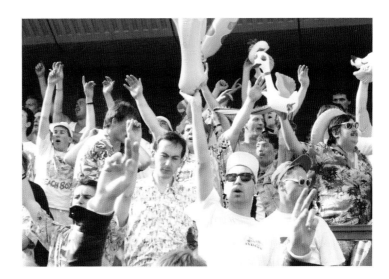

WHEN FOOTBALL WAS FUN!

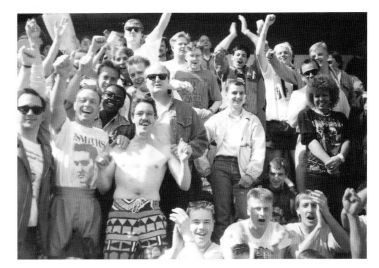

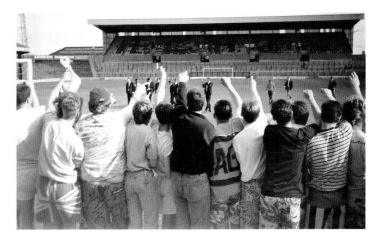

The players return to the pitch thirty minutes after the final whistle.

1990s

We started the 1990s finishing fifth from bottom of Division Two under Brian Talbot. Surely things couldn't get any worse? Unfortunately they did: in 1990/91 we were infamously dumped out of the FA Cup by non-League Woking. Exit Talbot, enter Bobby Gould. The season ended with relegation to the third tier for the first time in the club's history. Our inaugural season in the Third Division ended with a disappointing seventh-place finish. The fans demanded a change. In came Ossie Ardiles to lead us out of the rebranded Division Two at his first attempt with a play-off victory over Port Vale at Wembley. Ossie left when Spurs came calling and Keith Burkenshaw took the reins, just about keeping us in the division with a dramatic last-day victory at Portsmouth. Alan Buckley eventually took over, followed by Ray Harford and Denis Smith. For the rest of the decade we hovered around the middle to lower half of Division One (second tier). One disappointing season followed another. There were some great away trips though…

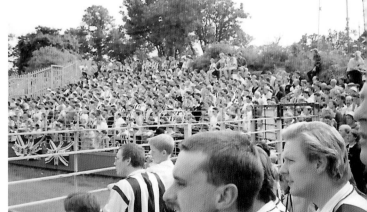

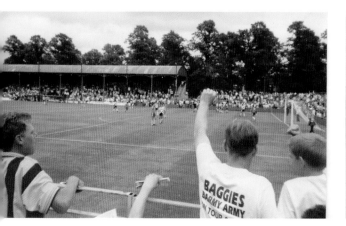

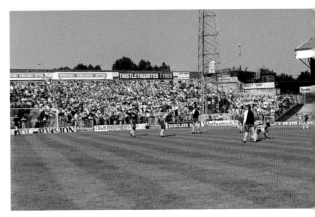

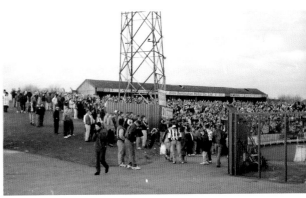

Opposite, top left: The infamous Tim Buzaglo is chaired off the pitch by Albion fans following our 4-2 FA Cup defeat to non-League Woking. 05.01.91

Opposite, top right and bottom left: First away game of our first season in the third tier: A 1-0 victory over Darlington before a crowd of 5,658 at their old Feethams ground. 24.08.91

Opposite, bottom right: Derek Murphy, Andrew 'Boo' Freeborn, Graham Dring and Gary Mottram at Bolton, 1991.

Top: Albion fans in the Supermarket End at Bolton's old Burnden Park. 07.09.91

Second from top: The luxurious away end at Wigan's old Springfield Park – a muddy grass bank! A Boxing Day victory in 1991.

Second from bottom: 'Silk Out': Albion fans in the away end at Exeter for a 1-1 draw. 28.12.91

Bottom: Plainmoor, Torquay, for our 1-0 defeat on 04.01.92. Oh dear!

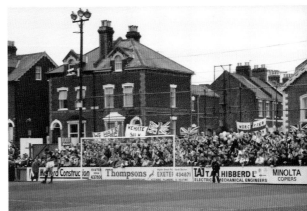

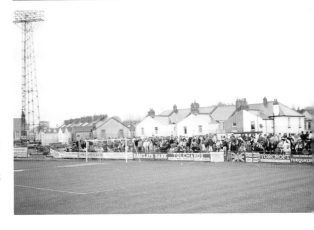

Barnsley
Drew 2-2
Division 2
Att: 10,334
Oakwell
28 April 1990

The second annual beachwear party saw 3,000 Albion fans converge on Yorkshire for the last away game of the season. The majority of the travelling Baggies dressed up accordingly; the weather was kind and a great day out was had by all. The draw assured our Second Division safety – we finished fifth from bottom. Bizarrely our fans stayed behind after the game and demanded that the players come back out onto the pitch – you would have thought that we had won the League!

Left: The Woodman Beach Crew arrive in Barnsley.

Below left: Neil Whitehouse, Paul Hutchinson, Gary Penn, Dean Walton, John Bishop and Neil Grainger.

Below right: Steve Heeley took his new girlfriend to the game!

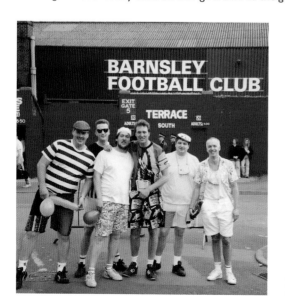

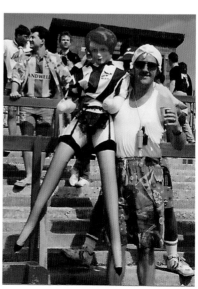

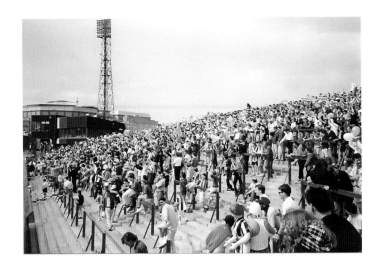

Let's get this party started! Albion fans start to fill the away terrace.

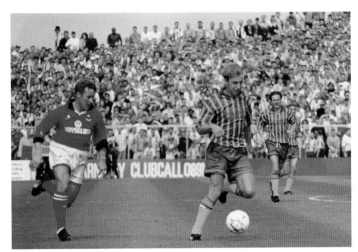

Kevin Donovan with the packed away terrace in the background.

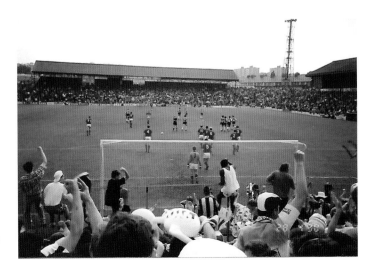

Albion fans celebrate Darren Bradley's goal.

**Newry Town/
Shelbourne
Won 3-1/Drew 1-1
Pre-season Friendlies
Att: 1,650/3,065
The Showgrounds/
Tolka Park
8/11 August 1990**

After drawing 0-0 with Glentoran and beating Ards 4-0, Albion headed for Newry, just north of the border. It was not long after the 'troubles' and the match was played before the surreal sight of armed patrol vehicles, gun-wielding police and helicopters overhead. Few Albion fans travelled but those that did were made very welcome in the Newry Supporters Club. Next stop Dublin and a far safer environment. A poor display from Brian Talbot's men against Shelbourne was soon forgotten as the Guinness flowed on a great night in the Irish capital.

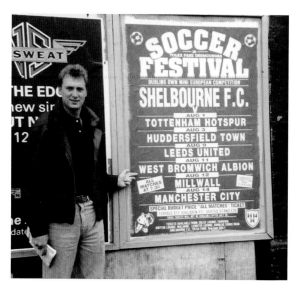

Top left: What a line-up for a few days in Dublin: Tottenham, Huddersfield, Leeds, Millwall, Man City and us. Carnage in the capital?!

Above: Andy Miller, Chris Edwards, Paul Dubberley and Bill Ahearne with Bill's Dublin-based Uncle Dave.

Below left: Armed police patrol at Newry Town.

Below: Albion line-up in Newry.

Above left: Boo Freeborn and Gary Mottram en route to Bournemouth, 1992.

Above right: Roger Burns and David Taylor with Jeff Astle.

Below: 2,000 Albion fans stay behind in the Brummie Road to protest after another defeat, this time at home to Orient. 03.01.92

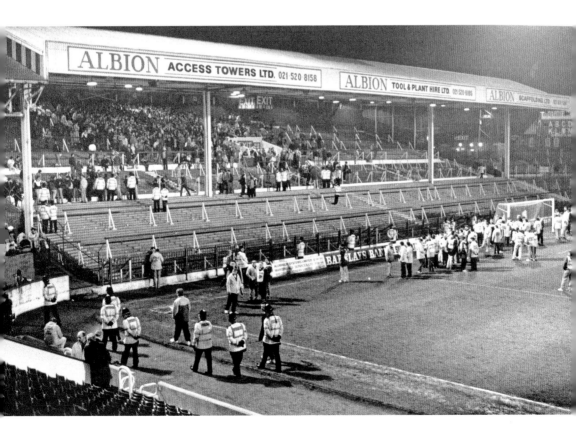

Bristol Rovers
Drew 1-1
Division Two
Att: 7,595
Twerton Park, Bath
11 May 1991

The bleakest day in the club's history: subject to results elsewhere, we needed a win to avoid dropping to Division Three for the first time ever. However, it was still the last game of the season, which was always an excuse to dress up! Rovers were temporarily playing in the Roman city of Bath, so it was 'Togas at Rovers' with bed sheets at the ready. Tickets were like gold dust and it was soon evident that Albion fans had infiltrated every corner of the tiny non-League stadium, many spilling onto the pitch before the game had even started. Jeff Astle stood with the Baggies fans as we witnessed a pathetic draw and relegation. A pile of togas formed a funeral pyre on the terraces at the end of the game and a few tears were shed.

Top left: All hail The King. Jeff Astle mixes with the fans before the game.

Bottom left: Mooner's toga crew on tour.

Bottom right: The Gloucester Baggies suitably attired.

SAD DAY
IN BATH

Below: Teresa Hill sums up the feeling amongst the fans. We were down to the Third Division for the first time in our history.

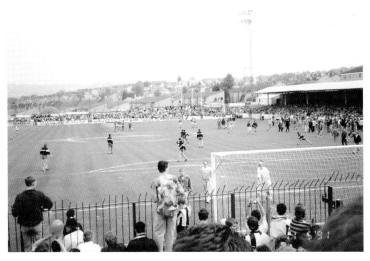

**Shrewsbury Town
Won 3-1
Division Three
Att: 7,742
Gay Meadow
2 May 1992**

Our first season in the Third Division had come to an end and a seventh-place finish just wasn't good enough. Bobby Gould had to go. Before the game Shrewsbury town centre was packed with beachwear-clad Baggies who witnessed the crazy sight of the players being led by Gould walking to the ground. A coffin procession followed and numerous banners displayed the fans' feelings. The game was merely a sideshow to events on the terraces as Albion fans filled three sides of the quaint Gay Meadow ground and demanded the removal of the manager; the coffin was even paraded around the perimeter track. Sadly the fans invaded the pitch with a few minutes still remaining and broke the crossbar, somewhat spoiling the day. Sure enough, Gould was dismissed shortly afterwards.

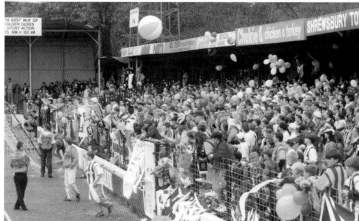

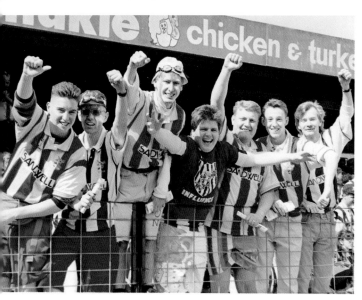

Above left: The famous coffin is paraded through the town before the game.

Above right, and left: Albion fans pack nearly three sides of Gay Meadow.

GOULD OUT

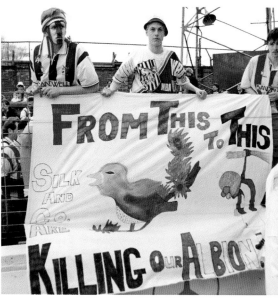

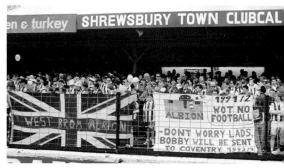

There was no doubt about the fans' feelings.
Changes had to be made; enough was enough.

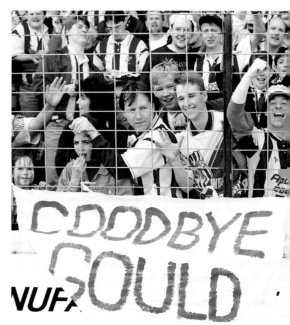

The Dalton Bank End at Huddersfield's old Leeds Road ground. Albion fans protested outside the main entrance after our dreadful 3-0 defeat. 28.05.92

A long Tuesday night trip to Plymouth Argyle and a 2-0 League Cup defeat on 19.08.92. Albion played in red and black hoops.

A night game at Brighton's old Goldstone Ground and a 3-1 defeat. 10.03.93

Another exotic location! Victoria Park, Hartlepool, before our 2-2 draw. Chris Ward, Stan Goodson, Phil Higley, Andrew 'Boo' Freeborn, Garry Mottram and Gareth 'Taff' Davies. 20.03.93

Albion fans totally outnumbered the home fans in our run-in to promotion at Chester City's Deva Stadium. 10.04.93

Albion fans take over three sides of Field Mill and make up the majority of the 6,659 crowd to cheer the lads on to a 3-0 victory against Mansfield Town. 17.04.93

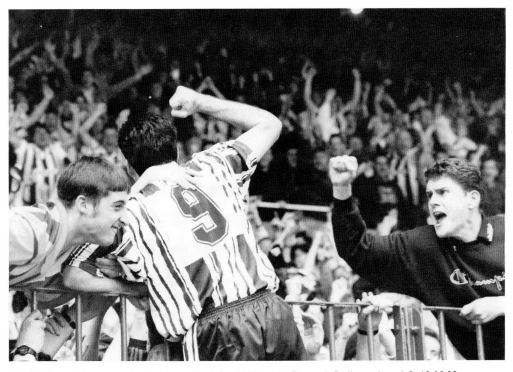

Bob Taylor celebrates with the fans at Stoke's old Victoria Ground. Sadly we lost 4-3. 19.09.93.

Rotherham United
Won 2-0
Division Two (Third Tier)
Att: 8,059
Millmoor
1 May 1993

With a Wembley play-off place already secured, Albion fans converged on South Yorkshire in party mood. Beachwear, inflatables and fancy dress were the order of the day as half the old Millmoor ground were filled with colourful Baggies. Bob Taylor and Paul Raven scored the goals in a routine victory and the party continued.

Above left: Richard Greenhough and Barry Swash in front of yet another pub heaving with thirsty Baggies.

Above right and below: Adding a bit of colour to the famous alley behind the away end at Millmoor.

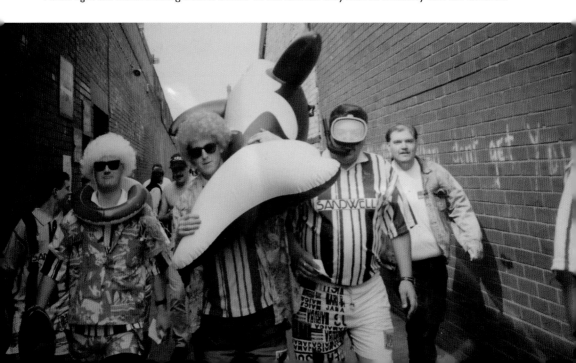

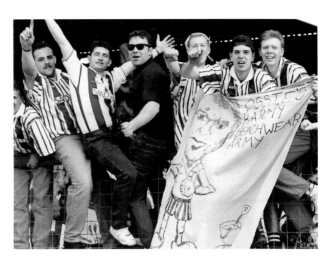

ALBION FANS IN PARTY MOOD AT MILLMOOR WITH THE PLAY-OFFS LOOMING

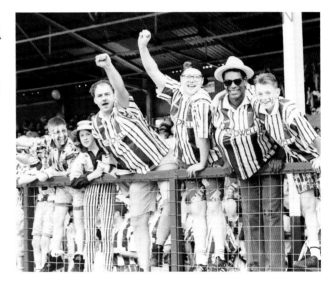

Swansea City
Lost 1-2
Division Two Play-off
 Semi-Final First Leg
Att: 13,917
Vetch Field
16 May 1993

After ending the season on a high with three wins, thousands of Albion fans headed for the Valleys in confident mood. We were just two games from Wembley; surely nothing could go wrong? But it's Albion that we're talking about and before we knew it we were 2-0 down. Then out of nowhere, in the Vetch Field mud, an own-goal gave us hope.

Swansea City
Won 2-0
Division Two Play-off
 Semi-Final 2nd Leg
Att: 26,045
The Hawthorns
19 May 1993

And so to the second leg. On a memorable night at a packed Hawthorns there was only going to be one outcome. The Albion fans cranked up the volume to create an unforgettable atmosphere. Despite a few twists and turns, goals from Hamilton and Hunt sent us to Wembley for the first time since 1970. The famous 'boing' caused the Brummie Road terrace to move up and down 3 inches under the strain. An emotional pitch invasion followed at the final whistle. 'Boing Boing, going to Wembley.' What a night!

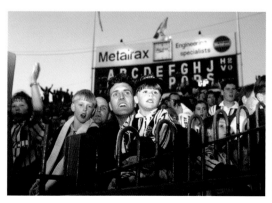

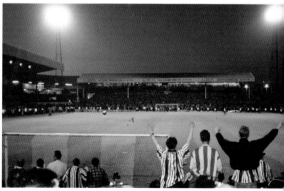

**Port Vale
Won 3-0
Division Two
Play-off Final
Att: 53,471
Wembley Stadium
30 May 1993**

We were back at Wembley for the first time in twenty-three years and determined to enjoy every moment. The demand for tickets meant that we could have filled the old stadium by ourselves. Unfortunately Port Vale wouldn't let us have any of their sections, which resulted in a very lopsided stadium. Albion's 43,000 totally packed half the ground while Vale's pathetic following were scattered around the other end. The first half was a fairly subdued affair; then came the turning point: Vale's Peter Swann got his marching orders and the Baggies turned up the pressure. Goals from Andy Hunt, Nicky Reid and Kevin Donovan secured promotion for Ossie Ardiles' side. We danced and we sang; we were going up!

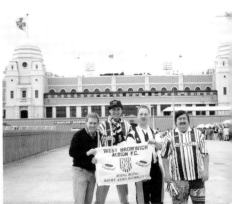

Above left: Jeremy Williams, Rita Williams, Andy Matthews, Chris Matthews, Amanda Matthews and Josh Turner soak up the atmosphere outside Wembley.

Above, top right: Gloucester Baggie Richard Brown – dressed for the occasion.

Above, bottom right: Chris Edwards, Dean Walton, Michael 'Silve' Silvester and Paul 'Dubsey' Dubberley outside the famous Twin Towers.

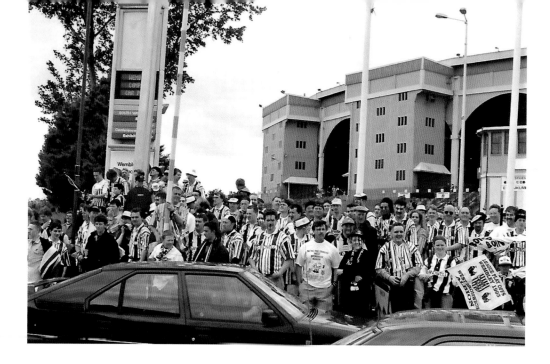

WHAT
A DAY!

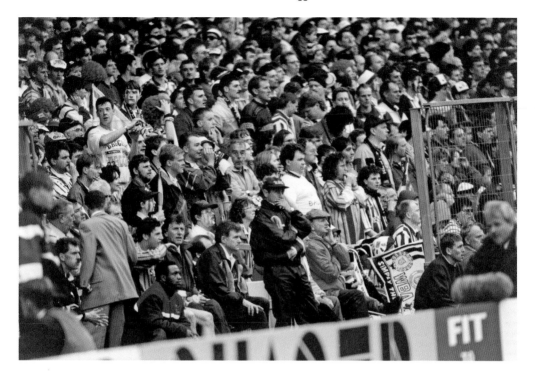

Above: Ossie Ardiles amongst the Albion fans.

Right: We've done it – we are going up!

Below right: The celebrations continued with a civic reception at Sandwell Council House.

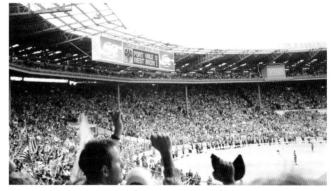

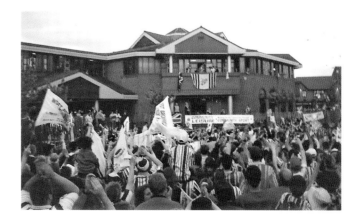

Fiorentina
Lost 0-2
Anglo-Italian Cup
 Group B
Att: 7,808
Stadio Comunale
 Artemio Franchi
16 November 1993

The resurrected Anglo-Italian Cup saw Albion lose all four group games; however a trip to Florence was too good an opportunity for a few hundred diehard Albion fans. The away section was boosted by a few England fans who were in Italy for the San Marino game the following evening. On a bitterly cold night, Albion put up a brave display but the 'Viola' strolled to a 2-0 victory. The bar opposite the stadium was full of thirsty Baggies before and after the game.

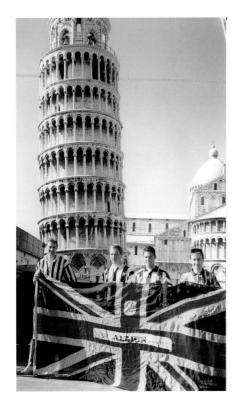

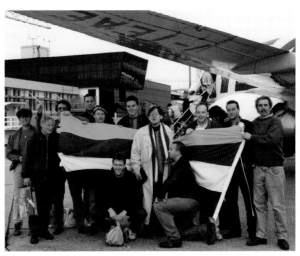

Left: A stop-off in Pisa on the way to Florence: Dean Walton, Michael Silvester, Steve Conabeer and Tony Jones.

Above right: Some Albion fans flew in for the game.

Below left: Bar Stadio was full of Albion fans before and after the game.

Below right: Inside the Stadio Comunale Artemio Franchi.

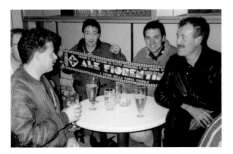

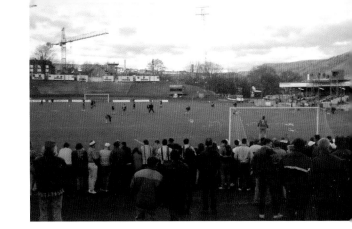

Humiliation at The Shay, losing 2-0 to Halifax in the FA Cup. 14.11.93

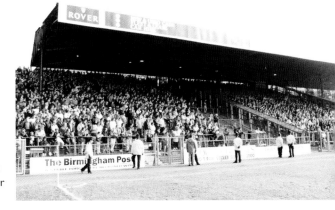

What a state the Blues' ground used to be! Here are the Albion fans on the Tilton Road terrace at St Andrews witnessing our 2-0 defeat. 28.12.93

Albion supporters team 'The Strollers' in 1994.

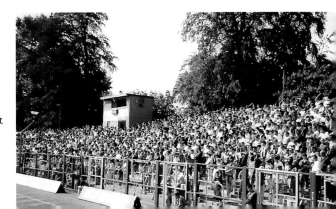

Albion fans on the Cuckoo Lane terrace at Oxford's old Manor Ground, this time for a 1-1 draw. 12.04.94

Grimsby Town
Won 1-0
Division One
Att: 16,870
The Hawthorns
30 April 1994

A sad day as we said goodbye to the famous Brummie Road End terrace. The Smethwick End had been rebuilt and now it was time for the Brummie to be demolished. Many happy memories of this legendary terrace came flooding back as we watched Kevin Donovan score the only goal to give us an important 1-0 victory.

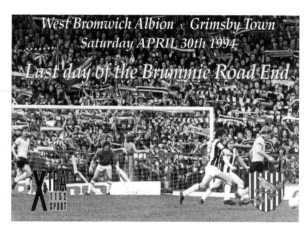

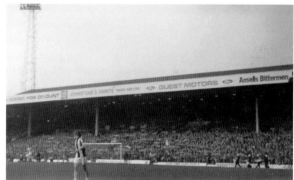

Left: Willie Johnston with a packed Brummie Road End in the background.

Below: The author in 1981.

Below left: The Brummie Road's last stand.

Portsmouth
Won 1-0
Division One
Att: 17,629
Fratton Park
8 May 1994

So how did we end up in this position? After the euphoria of promotion the previous season, Ossie had left us for Spurs and Keith Burkinshaw was now in charge. We had to win at Pompey to avoid slipping back into the third tier. This game was massive, resulting in over 10,000 Albion fans heading down to the south coast. Every pub in the vicinity of Fratton Park was heaving with Baggies from midday and queues began to form outside the away end. The massive Albion following urged the team on to a 1-0 victory thanks to a Lee Ashcroft header. The final whistle was a signal for the relieved beachwear-clad Baggies to invade the pitch. Another legendary away day.

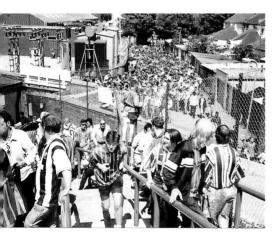
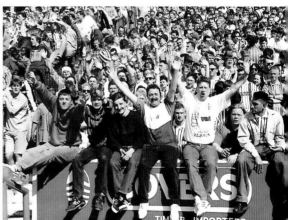

UNBELIEVABLE SUPPORT

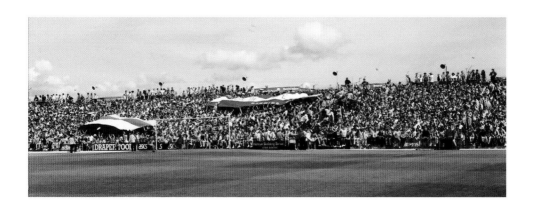

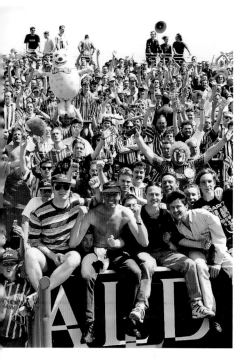

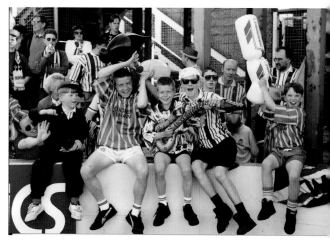

BAGGIES
INVASION
OF POMPEY

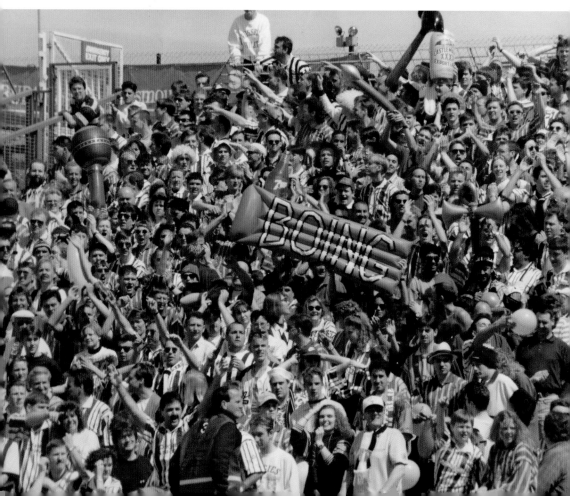

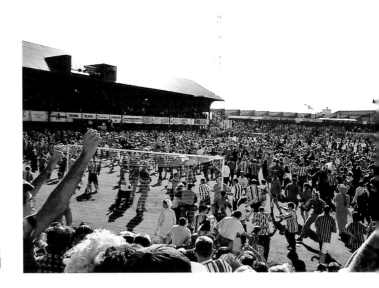

WE ARE STAYING UP!

The Fratton Park pitch soon filled up with jubilant Baggies at the final whistle.

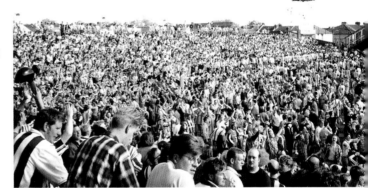

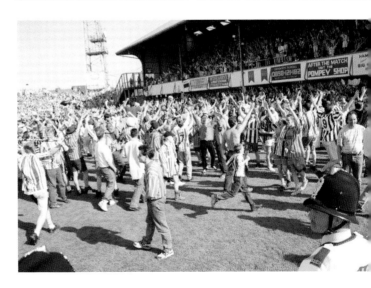

Sunderland
Drew 2-2
Division One
Att: 18,232
Roker Park
7 May 1995

Another poor season didn't prevent 3,000 Albion fans travelling to the old Roker Park for the now traditional end-of-season beachwear party. With Alan Buckley's Albion in nineteenth place and Sunderland in twentieth, the game was really a non-event. A 2-2 draw was played out as a party on the away terrace was in full swing.

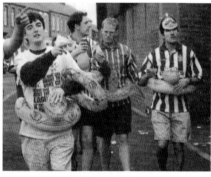

Where's the beach?

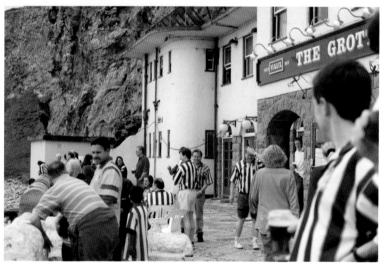

The Grotto at Marsden before the game.

Outside the old Roker Park.

Jayne Sant, Lesley Anslow, Steve Sant, Tony Smith, Richard Scrivens and Gaz McCormack with other Baggies in traditional end-of-season party mood.

Once again, the away end is packed for the last away game of the season.

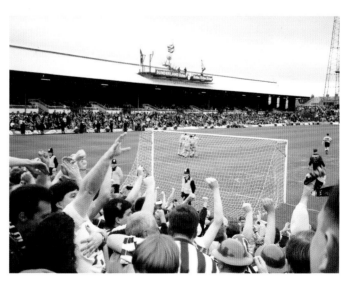

Celebrating Andy Hunt's goal in the 2-2 draw.

Brescia
Won 1-0
Anglo-Italian Cup
Att: 196
Stadio Mario
 Rigamonti
13 December 1995

A game played in bizarre circumstances – the pitch was covered in a few inches of snow and Albion fans made up half of the meagre crowd of 196. Just as we were preparing for the long drive back across the Alps, Bob Taylor hit an 87th-minute winner. At the final whistle the players came over for a snowball fight with the freezing cold fans. Bonkers night!

Steve Myatt, Glynis Wright, Richard Ryan and Glenn Willmore arrive in Brescia by train.

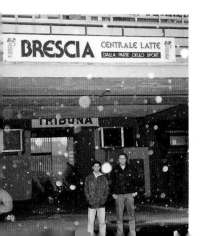

Left: Freezing cold in Brescia.

Far left: Steve Conabeer and Dean Walton arrive at Stadio Mario Rigamonti.

Martin Tonks, Fraser Allen and Carlo from Darlo welcome the warmth of the bar before the game.

Back row: Hamilton, Naylor, Burgess, Taylor and Raven. Front row: Edwards, Donovan, Smith, Gilbert, Darby and Rees.

'Sauce' with the 100 or so gallant Baggies.

Wigan Athletic/ Port Vale/Bury Won 1-0 /Won 2-0/Won 1-0 The Manx Cup Att: 1,445/843/854 Ballacloan Stadium/ Castletown Stadium/The Bowl 23/24/27 July 1996

Albion competed in the Isle of Man International Football Festival along with five other clubs, and duly won the Manx Cup. Douglas, the capital of the island, was completely taken over by travelling Baggies with very few fans of the other team present. A good time was had by all and the surreal sight of Alan Buckley and the players training in the sea greeted hungover fans on the morning following the first game. Super Bob Taylor got the winner in the final and went on to lift the trophy.

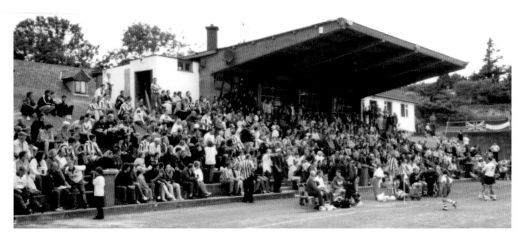

Above: The opening game v Wigan at Ballacloan Stadium.

Left: Graham Dring and Andrew 'Boo' Freeborn.

Below left: Super Bob lifts the trophy.

Below right: Albion fans on the grass bank at Castletown Stadium for the Port Vale game.

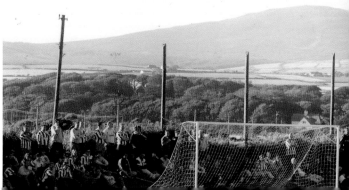

**Sheffield United
Won 4-2
Division One
Att: 21,248
Bramall Lane
25 April 1998**

Nothing really special about this game, just that many Albion fans wore fancy dress and some decided to go as old ladies! Goals from Andy Hunt, Kevin Kilbane and a Lee Hughes brace secured our victory. Another season came to an end, and a tenth-place finish in Division One for Denis Smith's men was achieved. Wolves' defender Keith Curle was voted Albion's Player of the Year for his own-goal that decided the Black Country Derby!

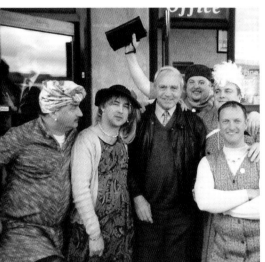 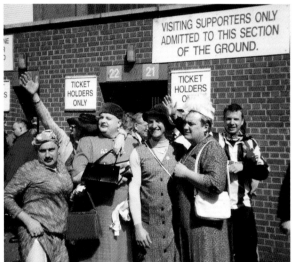

Above left and right: The King and the Astlettes.

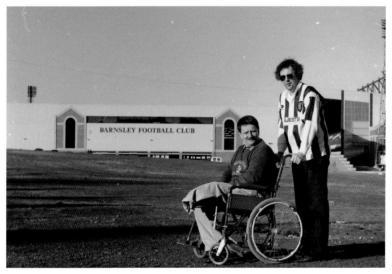

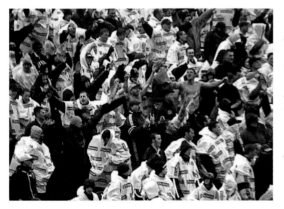

Top: When Richard Sneekes was on fire. Albion fans greet their new hero in a sell-out game at Carrow Road. Sneekes duly scored and Peschisolido bagged a hat-trick in our 4-2 victory over Norwich.

Middle: 'One-leg' Kevin Candon with Richard Ryan outside Oakwell before our 2-0 defeat. 28.03.97

Left: Monsoon at Swindon: Albion fans get a right good soaking during our 2-2 draw at the County Ground. 24.10.98.

Tranmere Rovers
Lost 1-3
Division One
Att: 10,540
Prenton Park
9 May 1999

The season had long since fizzled out for Denis Smith's team. Mid-table obscurity meant a meaningless end-of-season game in Birkenhead. But this is the Albion we're talking about, so 3,000 fans dressed up for a party in the away end at Prenton Park. It was just as well that the match was irrelevant; we didn't really compete and a rare Fabian DeFreitas goal was just a token as Tranmere scored three. Desperate days.

END-OF-SEASON PARTY TIME!

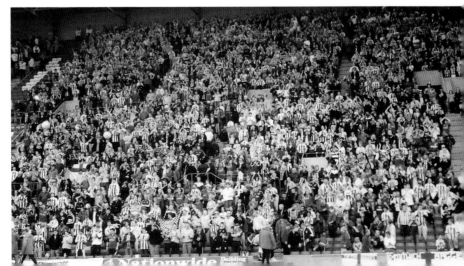

**Denmark
Pre-season Tours
1999, 2000, 2001**

Albion had formed a partnership with Danish club Greve, which led to three summer tours to Copenhagen and a chance to visit numerous grounds based in and around the capital. From the very first match, a special relationship was formed between both sets of fans that still exists to this day. Football matches were arranged between the supporters, coaches organised to take us to the games and barbecues were laid on. Denis Smith and Gary Megson both took their Albion sides to Denmark to pit their wits against various standards of opposition.

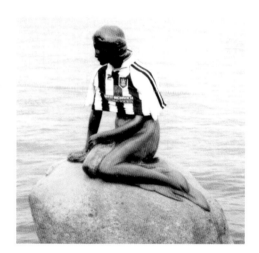

Above left: The Little Mermaid is an Albion fan!

Above right: Hans Christian Andersen poses with the travelling Baggies.

Left: Richard Ryan with Scandinavian Baggies Stian Bøe, Marianne Bøe and Olle Kannö outside our 'local' in Greve.

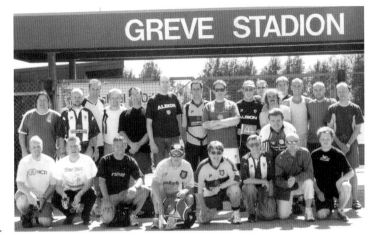

Albion and Greve fans wait to board the coach for our supporters game at Slagelse.

The Baggies supporters team.

Some great nights were had in Copenhagen.

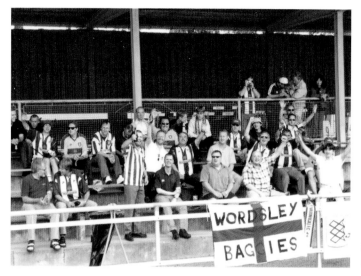

In Aabenraa for the game against Haderslev.

Greve Supporters Club (The Blue Wave) Chairman Benny Andersen with Kiwi Baggie Kevin Buckley and Dubsey.

A regular site at Greve FC.

2000s

Following Brian Little's short, unproductive time in charge, in March 2000 Gary Megson came in and things began to change. We just about managed to avoid relegation in his first couple of months but the following season we made it into the play-offs, losing out over two legs to Bolton. An incredible end to the 2001/02 season saw us pip Wolves to automatic promotion with memorable scenes at Bradford and The Hawthorns. Sadly, the Premiership was too big a task and we were relegated in our first season. 2004 and promotion was again secured, this time with a few games to spare. In October, Bryan Robson replaced Megson and after being rock bottom at Christmas, we beat Portsmouth in our last game to complete the 'Great Escape'. We had certainly become a yo-yo club and suffered relegation again the following season. Never a dull end of season in this decade, we then made it to the play-off final, Tony Mowbray's men disappointingly losing out to Derby at the new Wembley. No messing about in 07/08: we finished top of the pile, clinching the Championship at QPR. We even returned to Wembley with Portsmouth beating us in the FA Cup semi-final. We just couldn't hack it in the Premier League and finished bottom in 2009.

Right: The Australian branch get a visit from Albion Chairman Paul Thompson.

Below left: The massed ranks of Albion fans at the Stadium of Light for the lunchtime FA Cup victory over Sunderland (2-1). 05.01.02

Below right: A sweet victory in Dingle land. This time a Jordao goal gave us a 1-0 win. 02.12.02

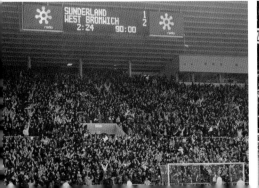

**Queens Park
Rangers
Drew 0-0
Division One
Att: 15,224
Loftus Road
29 April 2000**

In a nationwide survey, Albion supporters had been voted the worst-dressed fans in the country. Therefore the end-of-season theme just had to be 'Suits at Shepherds Bush' and a chance to show everyone our 'posh' side! A few thousand Baggies turned up at Rangers Stadium in suits and ties, accompanied by the girls in their best evening gowns. Who would have thought that we were on the brink of relegation again? A respectable 0-0 draw followed by a home victory against Charlton gave us a fourth-from-bottom finish and sent Walsall back to Division Two.

ARMANI ARMY!

Mick John, Andy Trafford, Joe John and Glynn Smith.

Mr and Mrs Rupert Middleton.

Liz and Gordon Massey.

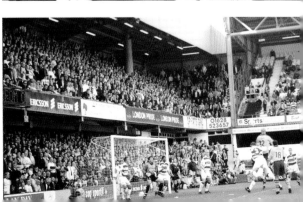

The away end at Loftus Road resembled a night at the opera!

**Preston North End
Lost 1-2
Division One
Att: 16,226
Deepdale
6 May 2001**

An array of Baggies in fancy dress greeted Gary Megson's men as they ran out in the Lancashire sunshine. With our place in the play-offs already confirmed, the pressure was off and the usual end-of-season party atmosphere prevailed. We went down 2-1 despite a Neil Clement special. Sadly we didn't fare any better in the play-off semi-final against Bolton, throwing away a two-goal lead at home followed by a 3-0 defeat at the Reebok. Our support at Bolton was absolutely unbelievable. I think that we all knew the good times were just around the corner.

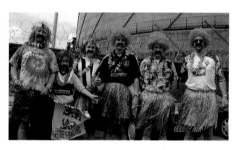

Left: Ginger wigs were aplenty in tribute to the gaffer.

Below: The old Pavilion Stand at Deepdale, packed with partying Baggies.

Sheffield United
Won 3-0
Division One
Att: 17,653
Bramall Lane
16 March 2002

The 'Battle of Bramall Lane' has gone down in Albion history. The game was abandoned in the 82nd minute after the Blades had been reduced to SIX men – three had been sent off and two taken off 'injured'. The result was eventually allowed to stand, rightly securing three precious points on our way to promotion. It was always going to be a bit tasty with Gary Megson facing Neil (Colin) Warnock, but nobody could have predicted this. Goalkeeper Simon Tracey was sent off in the 8th minute and Albion were soon 2-0 up. When substitute and former Baggie Georgos Santos entered the field he immediately lunged into Andy Johnson and was also red-carded. Then United's second substitute received a straight red for headbutting Derek McInnes. After Scott Dobie scored Albion's third, two United players mysteriously left the field, supposedly injured. This was the first time in 114 years of Football League history that a game had to be abandoned due to a lack of players. A truly crazy afternoon.

Above left: The Albion fans are totally bewildered by events on the pitch.

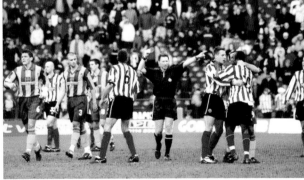

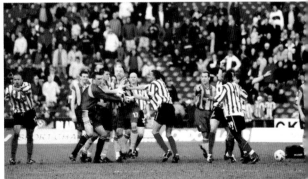

Nottingham Forest/
Coventry City
Won 1-0/Won 1-0
Division One
Att: 24,788/21,513
City Ground/
Highfield Road
22 March/1 April
2002

Gary Megson's team had started to gain momentum and Wolves were wobbling. These two away games were massive in our race for promotion, and remarkably similar. Thousands of Baggies at each venue created a fantastic atmosphere and urged the team on to victory in both matches, with Super Bob grabbing the two winning goals. We could sense blood and the Dingles knew it!

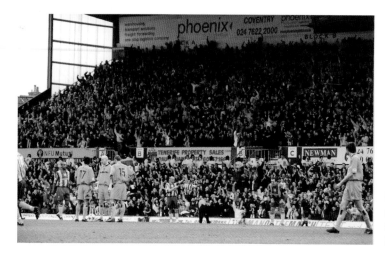

Bob Taylor grabs the winner and the Albion fans celebrate at Coventry's old Highfield Road ground.

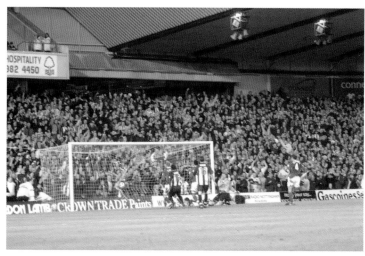

Another Super Bob winner in front of the Baggies fans at the City Ground.

**Bradford City
Won 1-0
Division One
Att: 20,209
Valley Parade
13 April 2002**

We needed to win our last two games to guarantee promotion to the Premiership. 6,500 travelling Baggies descended on Yorkshire, plus many more without tickets in amongst the home fans. In tribute to Darren Moore (Big Dave) lots of Albion fans were dressed as the character from the Pot Noodle TV advert. In a hard-fought game it seemed that we were heading for a scoreless draw when Bob Taylor was chopped down in the 94th minute and a penalty was awarded. Delight … then panic as it dawned on everyone that penalties were not our forté – we had missed eight out of our previous eleven spot-kicks. Then cometh the hour, cometh the man. Up stepped Slovakian international Igor Balis, who calmly slotted the ball home and became an instant folk hero. The fans went crazy! On to Crystal Palace at home to seal promotion.

Above left: Tribute to Big Dave.

Above right: Igor, Igor!

Wayne 'Bear' Ferris joins in the celebrations following Igor's penalty.

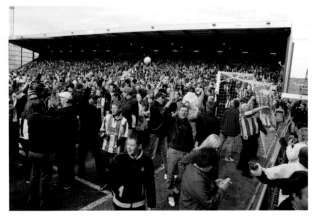

Pitch invasion at the final whistle.

On to the Crystal Palace game and promotion.

Crystal Palace
Won 2-0
Division One
Att: 26,712
The Hawthorns
21 April 2002

There's nothing like a packed Hawthorns and a must-win game to get the adrenaline going. It had all come down to this last match of the season and victory would take us to the Premiership for the first time. Tensions were high as the fans roared the players on. Every stand was a mass of blue-and-white flags on an emotional afternoon. In the 17th minute 'Big Dave' put us ahead – sheer relief but there was still a long way to go. Then just as Sheffield Wednesday had taken the lead against Wolves, Bob Taylor pounced on the goalkeeper's fumble to put us 2-0 ahead. We had done it. The after-match scenes of joy will remain in the memories of everyone who was present that afternoon.

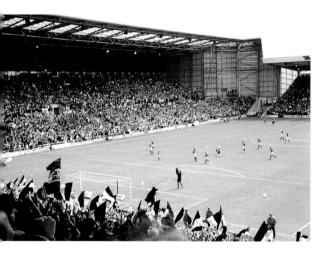

Above left and right, and below left: Premiership here we come.

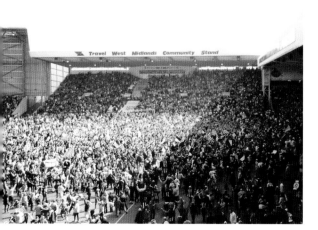

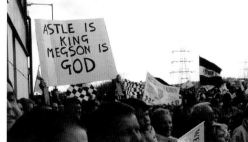

Civic reception at Sandwell Council House.

Blackburn Rovers
Drew 1-1
Premiership
Att: 27,470
Ewood Park
3 May 2003

Our first ever season in the Premiership had ended in disappointment: we had finished second from bottom and were returning to Division One. However, we had experienced a great adventure and if it wasn't for some very dubious refereeing decisions in favour of the top clubs we would have gained a few more points. In recognition of our favourite 'men in black' the theme for our last away game was referees. What a laugh we had, whistles blown for every challenge and red/yellow cards being waved at every opportunity. One Baggie turned up with a toilet seat around his neck – he had come as 'Urinal' Rennie! Oh, amongst all this madness a game was taking place and we actually played quite well, a Jason Koumas goal giving us a share of the spoils.

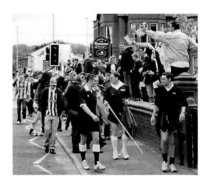

REFS AT ROVERS

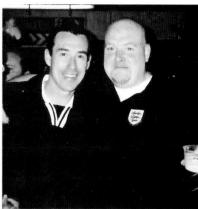

Above left: The late John Stanley with Nathan and Neil Reynolds.

Above right: Even Super Bob joined in the fun – seen here with Graham Dring.

Right: Colin Locke, Spence Locke and Gavin Burt.

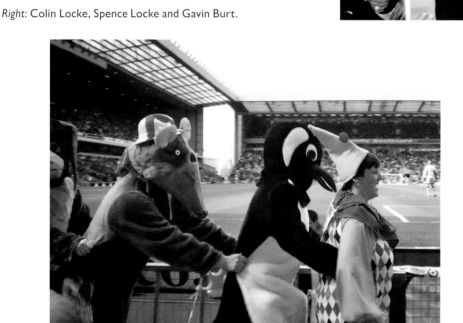

**Odense Boldklub/
FC Midtyjlland
Lost 1-2/Won 2-0
Pre-season Tour of
Denmark
Att: 2,223/1,500
Odense Stadion/
Horne Stadion
19/21 July 2003**

After a two-year break, we were back in Denmark again. In the birthplace of Hans Christian Andersen we struggled against top Danish side Odense on a lovely sunny afternoon. A Koumas penalty wasn't enough to prevent a 2-1 defeat. Our next game was at the seaside at the tiny Horne Stadium on the Danish coast. The ground wasn't much more than a park and chairman Jeremy Peace stood on a grass bank with the travelling Baggies. Second-half goals from Daniele Dichio and Lee Hughes gave us a comfortable win.

Above: An Baggies free-kick at Odense.

Below left: Russell Hoult signs autographs for Jade Walton and Steve Gravenall after the game in the coastal resort of Horne.

Below: Jade Walton secures the match ball after the game in Horne.

Reading
Lost 0-1
Division One
Att: 20,619
Madejski Stadium
1 May 2004

With promotion already secured, it was time for an end-of-season party, although technically it wasn't our last away game – we still had to visit Stoke in midweek. One of the stars of the season was our Danish defender Thomas Gaardsoe, so the theme for Reading was Vikings. The away end was a complete sell-out with the surreal sight of thousands of horned helmets totally confusing the home fans. Cries of 'Tommy, Tommy Gaardsoe' echoed around the 'Mad Stad', but the players were already on the beach and slumped to a 1-0 defeat.

VIKING INVASION OF READING

Above right: The Reynolds family.

Right: Viking family Connolly.

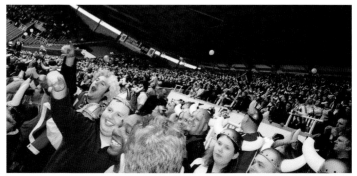

Portsmouth
Won 2-0
Premiership
Att: 27,751
The Hawthorns
15 May 2005

The Great Escape. Another rollercoaster afternoon at a packed Hawthorns. A surprising point at Old Trafford the week before had given us a glimmer of hope in our fight to beat the drop. The Pompey fans even cheered for us, as an Albion victory would send their rivals Southampton down. At half-time results elsewhere meant that we were still bottom of the pack. A miracle was required. Geoff Horsfield, on as substitute, put us ahead and on-loan Kieran Richardson put us two up; however the other results meant that we were still going down. Norwich and Southampton were both losing but Palace were beating Charlton. A huge roar suddenly swept around the ground. Charlton had equalised. Our game finished and everyone was glued to thousands of radios, the players waiting on the pitch relying on the fans to relay the news. Then it was over and most of the crowd (including the Pompey fans) filled the pitch in celebration. Manager Bryan Robson was covered in champagne and the party well and truly started. We were staying up!

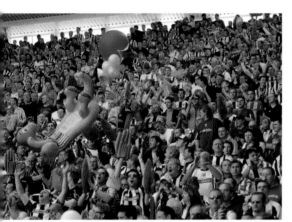
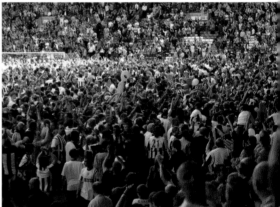

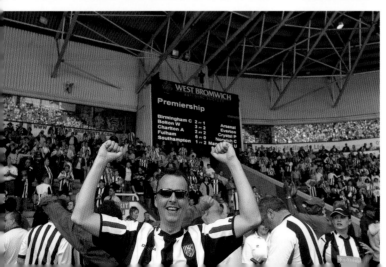

THE GREAT ESCAPE

Everton
Drew 2-2
Premiership
Att: 39,671
Goodison Park
7 May 2006

We had certainly become a 'yo-yo' team. Sadly we couldn't build on the Great Escape and we headed to Merseyside knowing that relegation had already been confirmed. Never mind, this was the last match of the season and with no pressure on, we could enjoy our trip to one of the old iconic football stadiums. Lots of Albion fans had dressed up and we nearly pulled off a shock. Goals from Gera and Martinez gave the Toffees a run for their money.

Wolverhampton
Wanderers
Won 3-0
FA Cup 4th Round
Att: 28,107
Molineux
28 January 2007

'Sold you seats for a pie and a pint' had its first airing long before kick-off. The reason being that Wolves' chief executive, Jez Moxey, had given us the whole of the South Bank, with the usual occupants being offered some food and drink as a token apology. The Dingles weren't happy and the Albion fans milked it to death. On the pitch we gave them a right good 3-0 spanking, securing our passage to the FA Cup fifth round. Just to rub salt in their wounds, the Albion fans left blue- and white-striped Tesco carrier bags covering the orange seats at the end of the game.

Coventry City
Won 1-0
Championship
Att: 26,343
Ricoh Arena
28 April 2007

We had already secured a place in the play-offs, so it was once again party time in the sunshine at the Ricoh. Ginger-haired Irish defender Paul McShane had been consistent for us all season, so an Irish theme was declared for our last away game (excluding the play-offs). Around 8,000 Baggies descended on Coventry, most of them kitted out in ginger wigs and all manner of Irish garb. This time, the players read the script and a Paul Robinson goal gave us all three points.

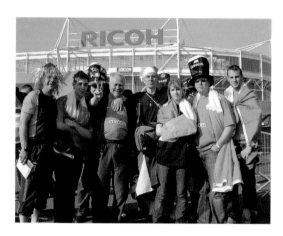

Another great end-of-season party.

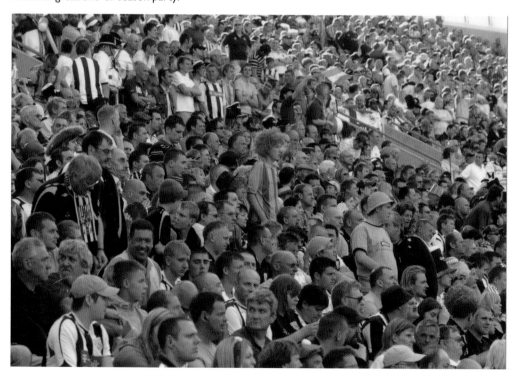

Derby County
Lost 0-1
Championship
 Play-off Final
Att: 74,993
Wembley Stadium
28 May 2007

After demolishing Wolves in the play-off semi-finals, we made our first visit to the new rebuilt Wembley Stadium full of confidence. Unfortunately we just never got going and a poor Derby team pipped us to promotion.

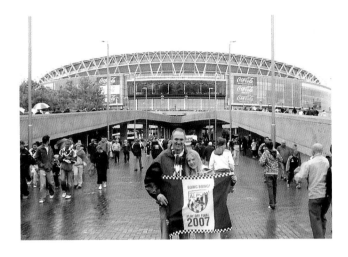

With my daughter Jade on Wembley Way.

Portsmouth
Lost 0-1
FA Cup Semi-Final
Att: 83,584
Wembley Stadium
5 April 2008

Back at the national stadium for the second time in under twelve months and we were drawn against Harry Redknapp's Portsmouth in our first semi-final appearance since 1982. We more than matched the Premiership team but they managed a lucky goal courtesy of former Baggies striker Kanu. No goals in two visits to the new stadium and no Cup final for us this year.

Eleven-year-old Ollie Thurogood before the game.

Queens Park
Rangers
Won 2-0
Championship
Att: 18,309
Loftus Road
4 May 2008

With promotion already guaranteed, we made our second end-of-season trip to Rangers Stadium with a mission to be crowned champions. It had been a great season and Tony Mowbray's side had been scoring goals for fun. The theme was 'superheroes' and almost all the travelling Baggies joined in the fun. Goals from Kim and Brunt got the party well and truly started and many a grown man shed a few tears as they witnessed Jonathan Greening lift the famous old trophy. The celebrations in front of the massed ranks of Albion fans went on long after the final whistle. A historic day; mission accomplished!

Left: Batman and Kevin!

Above: Alan Cleverley, Adrian Chiles, Sian Chiles, Frank Skinner and Bob Taylor.

Below left: Superheroes at Marylebone Station on the way to Loftus Road.

Below right: David Payne with his SuperKev mask.

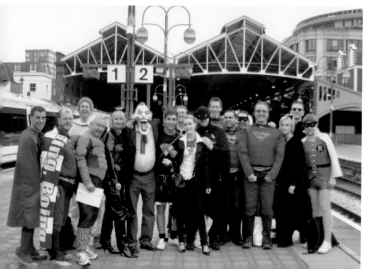

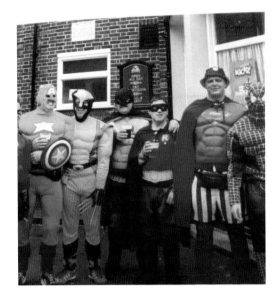

Denny McCarthy, Mal Burrows, Scott Clogan,
Garry Whitehouse, Eddie McCarthy, Steve
Whitehouse and Glenn Hillsmith.

C H A M P I O N S

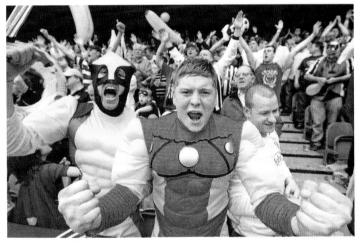

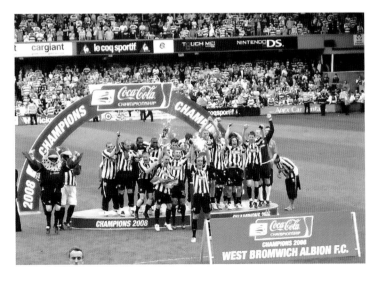

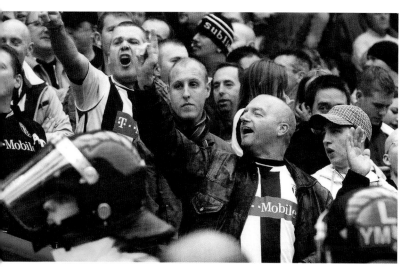

Above left: Trips to Molineux are always a bit feisty.

Above right: Albion fans on a regular pilgrimage to Dave Chapman's Albion pub in London.

Below: The Italians have arrived at The Hawthorns!

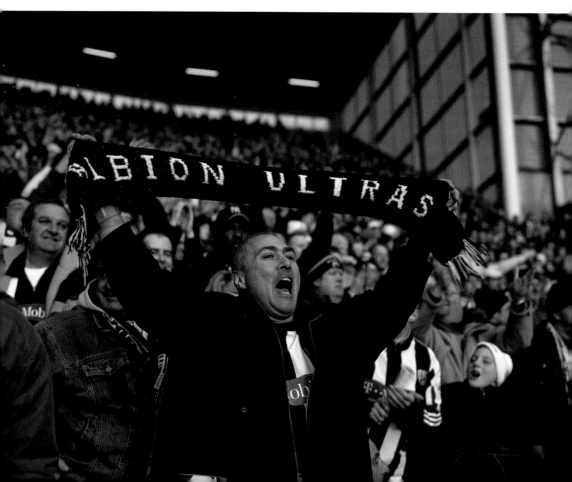

Borussia Monchengladbach
Lost 1-2
Pre-season Friendly
Att: 3,000
Hubert-Houben Stadion
6 July 2008

A week in Germany saw us lose two games against top German opposition. The first game was played in the picturesque town of Goch, where a Sherjill MacDonald equaliser couldn't prevent the Germans taking the honours. In the second game Cologne thrashed us 4-1 in Euskirchen. The author bagged surely one of the best bargains ever by flying to Germany for only ONE PENCE!

Above: Penny a flight.

Above right: Shane and Colin Bradley with Monchengladbach fans. Colin and Shane travel up from Cornwall for every home game.

Right: Cornish Baggie Shane Bradley flies the flag.

Proud to Be a Baggie

Left: Baggies eccentric Kev Wallace keeps the fans entertained.

Below: The Brummie Road End celebrates another goal.

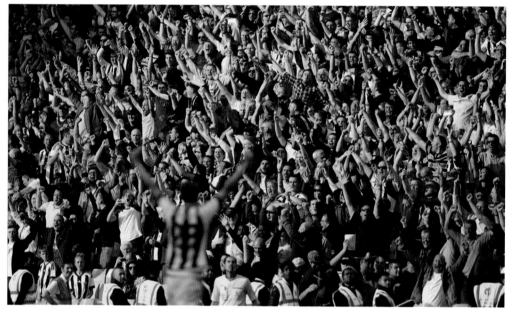

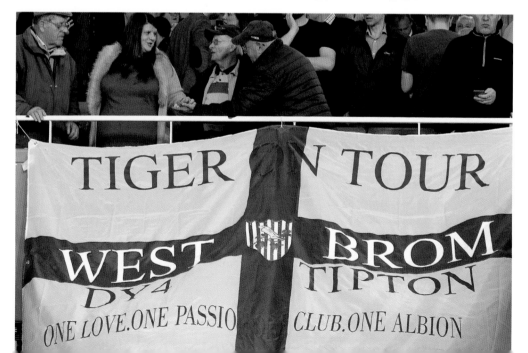

Blackburn Rovers
Drew 0-0
Premier League
Att: 28,389
Ewood Park
24 May 2009

If it's an end-of-season game at Blackburn then it must be relegation! For the second time in five years Ewood Park was the setting for our final away game. Although we had finished bottom in the Premier League, most Albion fans could see what Tony Mowbray was trying to achieve and wanted him to stay at the club. Mask-arade, a company ran by Baggies, gave a Mowbray mask to every Albion fan as they entered the ground, creating a unique sight for the *Match of the Day* cameras. After a forgettable 0-0 draw, Mowbray announced that he was off to Celtic – so much for the amazing support!

THERE'S ONLY 3,000 TONY MOWBRAYS!

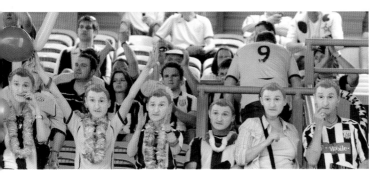

NK Nafta
Won 3-0
Pre-season Friendly
Att: 2,400
Lendava Sports Park
15 July 2009

We headed to the former Yugoslavia for a friendly against top Slovenian side NK Nafta. Around fifty Albion fans witnessed a straightforward victory courtesy of goals from Luke Moore, Jonathan Greening and Jonas Olsson on a lovely sunny afternoon.

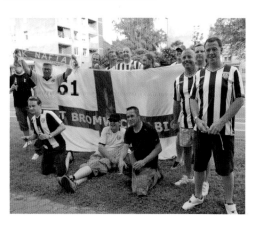
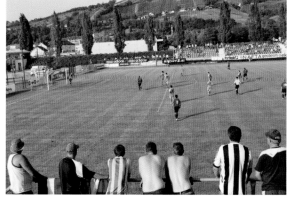

NK Varteks
Drew 2-2
Pre-season Friendly
Att: 1,800
Varteks Stadion
19 July 2009

After the stroll in Slovenia, the game in Varazin, Croatia, was a much tighter contest. Craig Beattie's two goals appeared to have given us victory before Varteks equalised in the 87th minute. Most of the Albion fans watched the match a bit the worse for wear (including Adrian Chiles) after shifting a few gallons of Croatian beer in the build-up to the game.

2010s

We started the second decade of the new millennium by finishing second in the Championship and gained promotion back to the Premier League. But could we stay there this time? We seemed to be heading the wrong way again until Roy Hodgson replaced Roberto Di Matteo in February. A respectable eleventh-place finish was bettered by a tenth-place one in Roy's first full season. England came calling and out went Hodgson; in came Steve Clarke and we managed our highest Premier League position in the 2012/13 campaign, finishing eighth. Midway through the 2013/14 season, Clarke was surprisingly dismissed and was eventually replaced with Spaniard Pepe Mel. We avoided relegation by three points. Alan Irvine was the new man in charge at the start of the 2014/15 season but his tenure was short and Tony Pulis was appointed in January 2015. Thirteenth place was secured, which was followed by fourteenth position in 2015/16 and tenth the following season. After a disappointing start to the 2017/18 campaign, Pulis was sacked in November and Gary Megson steadied the ship for two games before Alan Pardew was given the job.

Above left: Albion fans at Dunfermline on a pre-season tour of Scotland.

Above right: Supporters Club Chairman John Homer at Anfield.

Right: Pete Cashmore and his Albion-themed Far Post home pub.

Doncaster Rovers
Won 3-2
Championship
Att: 12,708
Keepmoat Stadium
10 April 2010

With four games still to play, we could clinch automatic promotion back to the Premier League with a victory at Donny. On a beautiful afternoon, the sold-out Albion allocation sang throughout the afternoon to cheer the lads to the required win. However mid-table Rovers put up a good fight. Fortunately Roberto Di Matteo's men did the business and goals from Dorrans, Brunt and Bednar saw us home – cue mass celebrations at the final whistle as we finished in second place behind Newcastle. Boing Boing!

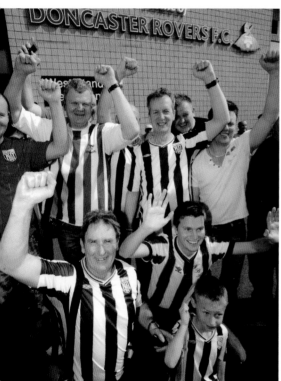

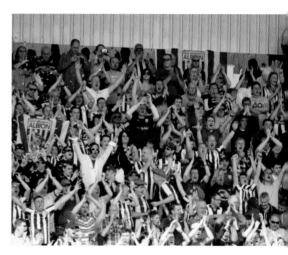

GOING UP!

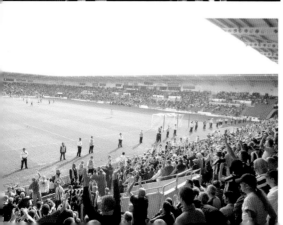

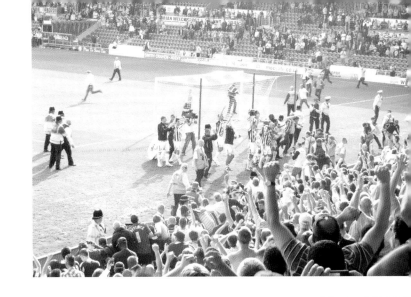

BACK
IN THE
PREMIER

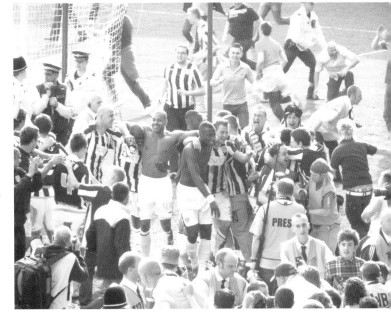

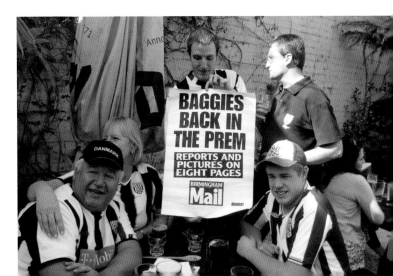

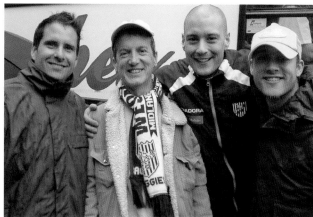

Top left: Victory at Villa Park is always sweet.

Left: Gary Hewitt, Jason Corley and Andy Bayliss with Frank Skinner.

Below: Sara, Rory and Aaron Taylor celebrate promotion in 2010.

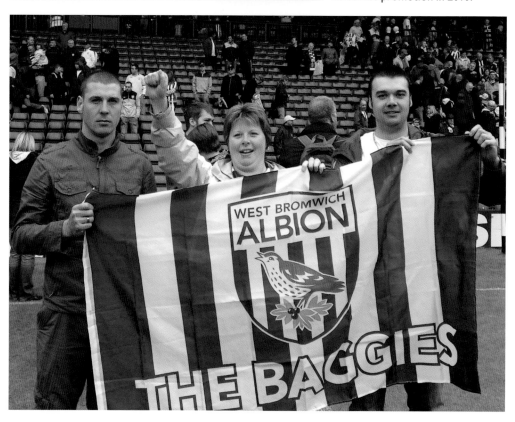

VVV Venlo
Won 2-1
Pre-season Friendly
Att: 3,112
Seacon Stadion De Koel
17 July 2010

In the summer of 2010, Albion spent a week in the Netherlands playing just one game, at the home ground of VV Reuver on the outskirts of Venlo. A few hundred thirsty Baggies filled the large beer tent and bonded well with the Venlo fans. Ishmael Miller put us ahead and Venlo equalised before a Gabriel Tamas bullet sealed the win. After the match, the two sets of fans got on so well that VVV Venlo have become something of a twin club. Their supporters have since visited Albion games and quite a few Baggies have been back to the Netherlands to support our new Dutch friends.

Above: Pre-season with the Albion is always a good excuse for a few beers; Venlo was no exception.

Right: Mark 'Snarka' Whitehouse.

Newcastle United
Drew 3-3
Premier League
Att: 51,678
St James' Park
22 May 2011

What a strange feeling: the last game of the season and nothing at stake! Time to honour an all-time Albion legend. The trip to Geordieland was declared 'Newcastle Brown Day' in tribute to the Baggies' great Tony Brown. Bomber masks were handed out, curly wigs were in evidence and there were many false moustaches on display up in the 'gods' at St James' Park. A disappointing first half saw us go 2-0 down to Alan Pardew's Magpies. The second half was a different story: Newcastle added a third shortly after the break but the unpredictable Somen Tchoyi managed to bamboozle the Toon defence and bag an amazing hat-trick, giving Roy Hodgson's Albion a precious point to secure an eleventh-place finish.

NEWCASTLE BROWN DAY

**San Jose
Earthquakes
Lost 1-2
Pre-season Friendly
Att: 6,872
Buck Shaw Stadium
13 July 2011**

Roy Hodgson decided to take his team on a twelve-day trip across the Atlantic Ocean. First up, California. The Earthquakes played in the college grounds in the nearby suburb of Santa Clara. Trials Bar in San Jose was established as the meeting place for the travelling Albion fans and our number was boosted by numerous 'Yankee Baggies'. A mad start to the game saw the Earthquakes keeper hoof the ball down the pitch and right over Boaz Myhill's head to give the hosts the lead. San Jose doubled their lead before Jerome Thomas pulled one back. A lovely afternoon basking in the Californian sunshine.

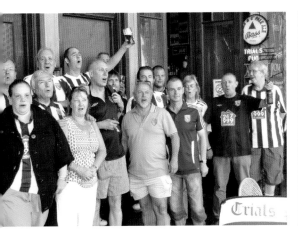 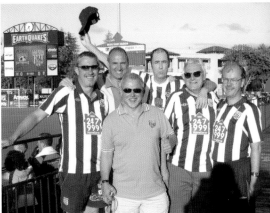

Above left: Our 'local' in San Jose: Trials Bar.

Above right: 'Rowley' Dave Bending, Deano, Kevin Wainwright, Sauce, Neil Reynolds and Norman Bartlam in Buck Shaw Stadium.

Right: Sauce's well-travelled flag.

Portland Timbers
Won 3-2
Pre-season Friendly
Att: 17,175
Jeld-Wen Field
21 July 2011

After beating Ventura County 4-2, we headed to Oregon where the Timbers stormed into a two-goal lead, each goal bizarrely celebrated by a lumberjack cutting through a large log with a chainsaw! James Morrison missed a penalty but also pulled one back. Somen Tchoyi got the equaliser before a Gabby Tamas pile-driver in the last seconds gave us victory.

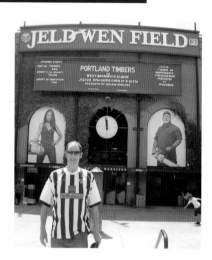

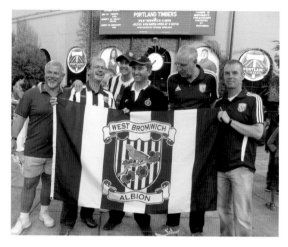

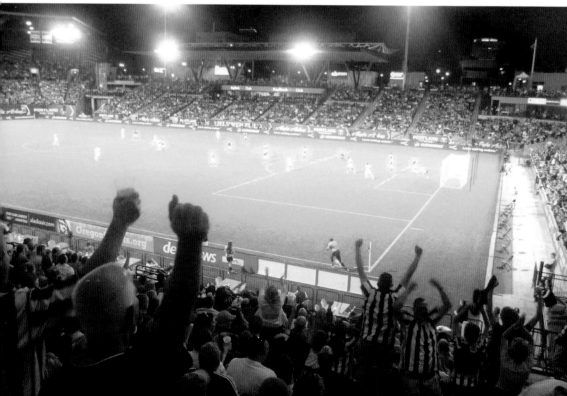

**Bolton Wanderers
Drew 2-2
Premier League
Att: 25,662
Reebok Stadium
6 May 2012**

Thanks to Roy Hodgson we had finally established ourselves as a mid-table Premier League team. Our relative success hadn't gone unnoticed and 'Uncle Roy' was offered the chance to manage the England national team – he couldn't refuse and his decision was respected. Our last away game was our chance to give him a good send-off with an England theme among other forms of fancy dress. The hosts took a two-goal lead before strikes from Brunty and Mozza gave us a deserved draw.

THANK YOU ROY

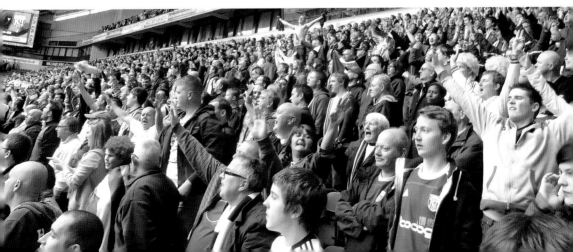

FF Malmo
Lost 0-1
Pre-season Friendly
Att: 3,128
Swedbank Stadium
19 July 2012

Around 600 Albion fans made the trip to Sweden to see new manager Steve Clarke take charge of the Baggies for the first time. Most fans headed for O'Leary's bar in the city centre for pre-match refreshments. A good sing-song was had by all and the pub was bedecked with Albion flags. The highlight of the lunchtime session was a 7-foot-tall Swedish policeman who kindly helped tie the flags to the bar canopy. On to the game and Malmo took the lead after only eight minutes and we missed numerous second-half chances, failing to prevent a 1-0 defeat.

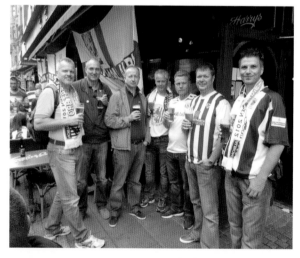

Above left: O'Leary's Bar packed with Baggies before the game.

Above right: Lee Fletcher and friends outside the Swedbank Stadium.

Left: With the Norwegian Baggies.

Below left : A tremendous following for a pre-season friendly.

FC Copenhagen
Won 3-0
Pre-season Friendly
Att: 3,197
Parken Stadion
25 July 2012

Back to our old stomping ground of Copenhagen. We made the short journey across the bridge from Sweden to Denmark for the second game of this mini-Scandinavian tour. Amongst the Baggies in the crowd were Adrian Chiles with daughters in tow, and a few Greve fans renewing old acquaintances. Goals from Steven Reid, Shane Long (penalty) and Gabriel Tamas gave us a 3-0 win, although in fairness it was an even contest.

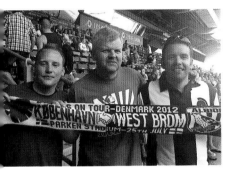

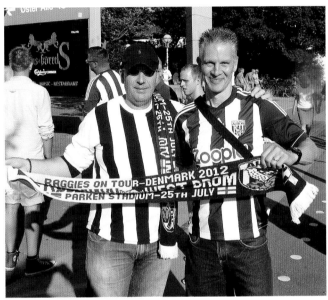

Above: Adrian Chiles with Chris and James Ewing.

Left: Ashley Starbuck and Jonathan Eden.

Below right: Kev Wainwright, Rowley Dave and Deano.

Norwich City
Lost 0-4
Premier League
Att: 26,837
Carrow Road
12 May 2013

Our star of the season had undoubtedly been our on-loan striker from Chelsea, Romelu Lukaku. At our last away game many of the Albion fans wore dreadlock wigs in tribute to our new hero. Sadly the players had already decided they were on the beach and meekly surrendered to the rampant Canaries.

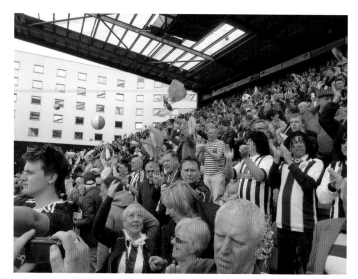

GOODBYE LUKAKU

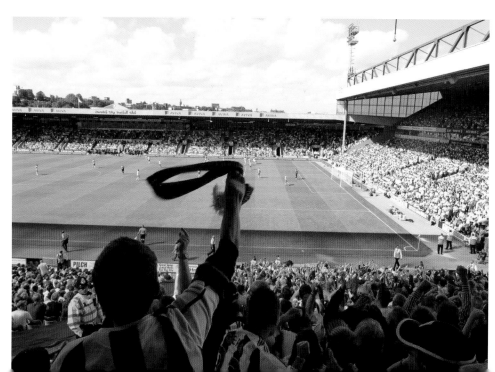

Hannover 96
Lost 1-2
Pre-season Friendly
Att: 512
Solarstadion der
Stadt
18 July 2013

Around 200 Baggies travelled to the picturesque Austrian town of Gleisdorf. With new signing Nicolas Anelka making his Albion debut, we more than matched our Bundesliga opposition; but despite a rare Markus Rosenberg goal, we succumbed to a 2-1 defeat. Most of the Albion fans headed back to their Vienna base after the game where a good time was had by all.

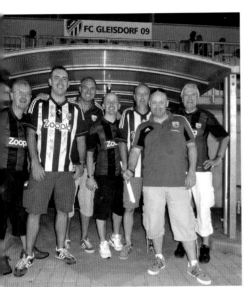

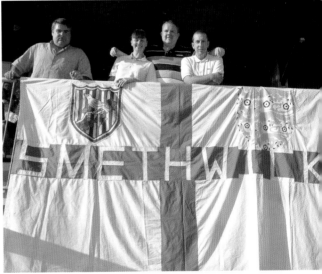

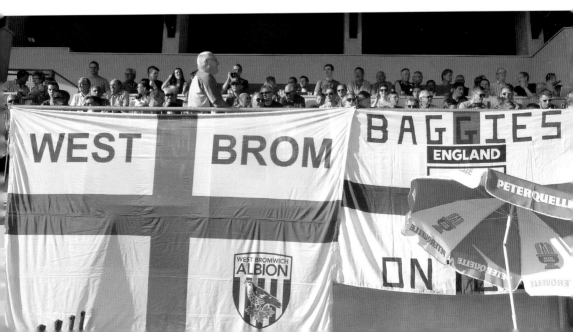

Ferenc Puskas Academy

Won 3-0

Pre-season Friendly

Att: 1,068

Felcsuti Sporkomplexum

22 July 2013

A short drive over the border from Austria into Hungary for our second friendly. Everyone headed for the lovely Sopron town square where we were joined by several of our friends from Venlo. After sampling plenty of the cheap local brew, the Baggies' fans headed for the match making plenty of noise. The game itself was a stroll for the Albion. Anelka scored twice and Graham Dorrans put away a late penalty.

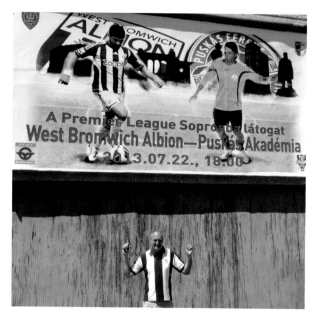

Above: 'Stockbroker' Dave Thornhill and Brian 'Crogie' Croghan.

Cork City
Won 6-0
Pre-season Friendly
Att: 2,121
Turner's Cross
6 August 2013

The pubs near the ground were full of thirsty Baggies before the game, many of them with Irish accents, excited about the opportunity of watching their heroes 'in the flesh'. The game itself was a non-event as Albion dominated throughout. Anelka bagged a hat-trick, Dorrans got two and local boy Shane Long got the other.

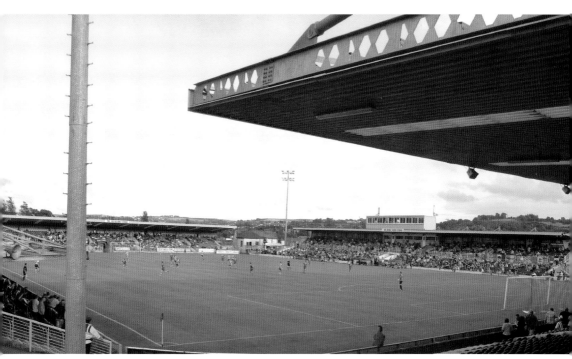

Arsenal
Lost 0-1
Premier League
Att: 60,021
Emirates Stadium
4 May 2014

Pepe Mel's last stand. Following the announcement that our popular Spanish manager would be departing at the end of the season, many Albion fans turned up at the Emirates in full Spanish garb. Matadors and flamenco dancers were just two of the outfits on display as Arsenal just about scraped a 1-0 win.

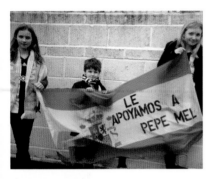

ADIOS PEPE

Above right: The Baggie girls, including Vicki Lloyd, Natalie Crew, Kirsty Fortnam, Becki Horton, Alice Court, and Sharron Crew, brightening up The Hawthorns.

Right: The much-missed Les James with Helen Allport.

Below: Albion fans Wounded Spirit recording at The Hawthorns.

Leicester City
Lost 2-3
Premier League
Att: 26,768
The Hawthorns
11 April 2015

ASTLE DAY. A book on West Bromwich Albion fans would not be complete without a tribute to Jeff Astle – The King of the Hawthorns. Jeff sadly passed away in 2002 aged just fifty-nine. His lovely family have worked tirelessly ever since to raise awareness of the brain damage that can be caused by heading the ball. The club supported the Jeff Astle Foundation by declaring the game against Leicester 'Astle Day'. The players wore replica 1968 FA Cup final strips and tracksuits, and the Brummie Road End held up placards spelling out 'ASTLE KING'. The match was almost irrelevant but we led 2-1 with goals from Fletcher and Gardner before City equalised and then Vardy turned party pooper by scoring the winner with virtually the last kick of the game. RIP Jeff; you will always be The King.

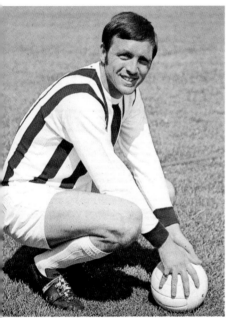

Left and below: Astle will always be The King of the Brummie Road.

Bottom left: Kev Wallace with his own unique tribute to The King.

Bottom right: David Cope, Dave Harrell, Snarka, Rowley Dave and the author with the 'Royal' Family, The Astles: Laraine, Dorice, Dawn and Claire.

Red Bull Saltzburg
Lost 1-3
Pre-season Friendly
Att: 700
Athletic Arena
8 July 2015

Albion head coach Tony Pulis and his squad flew to Austria for some serious fitness training. The workout included one game, played in Schladming against the Austrian champions. The players happily mingled with the travelling fans before the game. Although we had lots of possession, apart from Adil Nabi's goal we rarely threatened Saltzburg and if it wasn't for a string of first-half saves from Myhill, the scoreline could have been a lot worse.

Craig Bradley, Spencer Weston, Craig Myatt, Mark Evans, Mark Healy and Chris 'Tommo' Thompson.

Michael Ewing, Jon Kordas, Danny Grainger, Wozza Moore, Tony Malik, Drew Malik and Snarka Whitehouse.

Dutch Baggie Duco Van Der Veen.

Charleston Battery
Won 2-1
Pre-season Friendly
Att: 3,584
Blackbaud Stadium
17 July 2015

After losing in Orlando in the first match of the USA tour, next stop was South Carolina and a match against Charleston Battery. Albion fans were well looked after by the Battery staff: we were given a meal, match T-shirts, access to the club bar and taken on a tour of the highly impressive football museum in the main stand, which contained an unbelievable amount of English football memorabilia. The game was played at a slow pace in the intense heat. Saido Berahino opened the scoring just before half-time, then following Battery's equaliser, Brown Ideye netted an 82nd-minute winner.

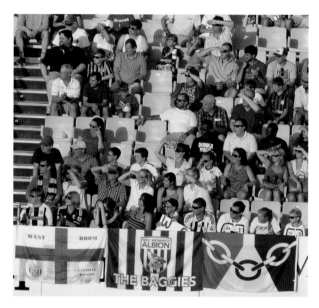

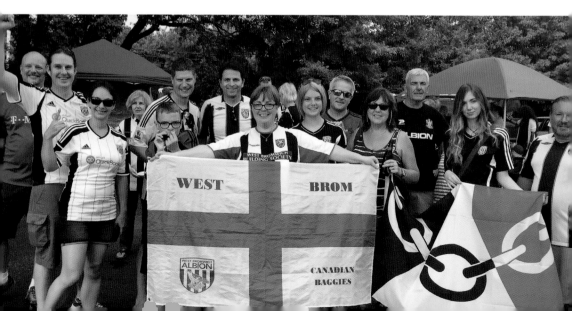

Richmond Kickers
Won 2-1
Pre-season friendly
Att: 6,832
City Stadium
19 July 2015

We headed up the east coast to Virginia for the final game of the tour. Albion fans were entertained outside the ground before the game, with US Baggies and Kickers fans inviting us to their tailgate parties. Inside the stadium the party continued with a band performing on a stage behind the main stand. A bizarre start to the game saw a thunderstorm brewing and the referee ordering both sides to leave the field after only six minutes. Nearly half an hour passed before the teams re-emerged after the storm had blown over. Shortly after the restart James McClean opened the scoring with a brilliant long-range effort. The game then followed a similar pattern to the Charleston match – the hosts equalised before Ideye again settled things with a far-post header.

BAGGIES IN THE USA

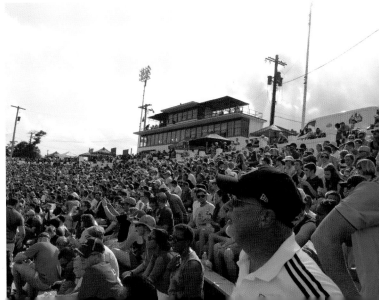

RCD Mallorca
Lost 0-1
Pre-season friendly
Att: 3,661
Iberostar Estadio
6 August 2016

A friendly in sunny Palma was too good an opportunity to miss. However the game was a stinker: Albion's only shot came from goalkeeper Ben Foster, who went up for a corner in the dying seconds. A real negative performance from Tony Pulis's team but the Baggies' fans behind the goal were kept amused by the antics of Mallorca-based Albion eccentric Kev Wallace, who came to the game dressed as our head coach.

Top left: Albion fans gather outside Estadio Iberostar.

Middle left: Norm, Deano and Dave.

Bottom left: Mallorcan resident Kev Wallace turned up dressed as Tony Pulis!

Below: Andy 'Parkesy' Parkes.

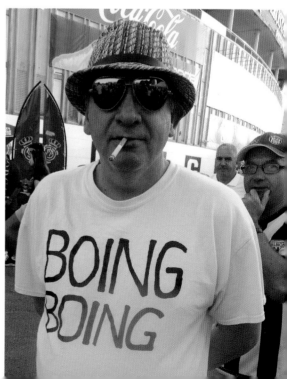

Vitesse Arnhem
Won 2-1
Fox Sports Cup
 Semi-Final
Att: 4,112
GelreDome
21 July 2016

Albion were invited to compete in a four-team tournament in Holland, featuring top Dutch sides Vitesse Arnhem, PSV Eindhoven and Portuguese side FC Porto. In the first game we were up against the hosts in the lovely city of Arnhem, made famous because of the battle in the Second World War and the film *A Bridge Too Far*. Albion put in a good performance and went through to the final with a 2-1 win. PSV beat Porto in the other semi and we all eagerly awaited the final two days later. Then news filtered through that the mayor of Arnhem had decided to call off the match because of possible trouble with the PSV fans. The Vitesse fans bought us drinks on the Saturday night and apologised for their 'insane' mayor.

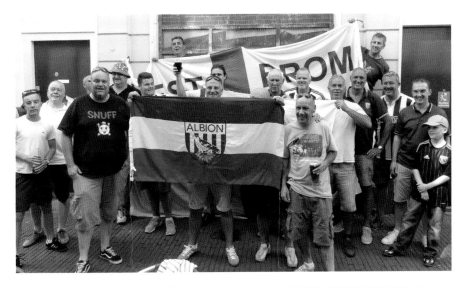

Above: Outside The Pegasus pub before the game.

Below: The travelling Baggies made plenty of noise in the GelreDome.

Right: Dean Walton, Steve Conabeer, Jonathan Eden, Norman Bartlam and Geoff Waters.

Leicester City
Drew 1-1 Lost 6-7
on penalties
Premier League Asia
Trophy Semi-Final
Att: est. 25,000
Hong Kong Stadium
19 July 2017

What a trip! A great time was had by all as around seventy Baggies met up in Hong Kong. Albion fans from Australia and China joined the regulars in our 'base camp', The Queen Victoria pub in Wan Chai. The semi-final pitted us against Leicester in the enormous stadium based in Happy Valley, where new signing Jay Rodriguez gave us the lead. Throughout the game the ground slowly filled up in anticipation of the main event – Liverpool v Crystal Palace (50,000 tickets sold to 'local' Reds fans). Unfortunately the Foxes levelled the scores and in a tense penalty shoot-out, young Sam Field missed his spot-kick and our chance of Cup glory was gone. Most Baggies didn't hang around to watch the second game. We headed back to the bright lights of Wan Chai!

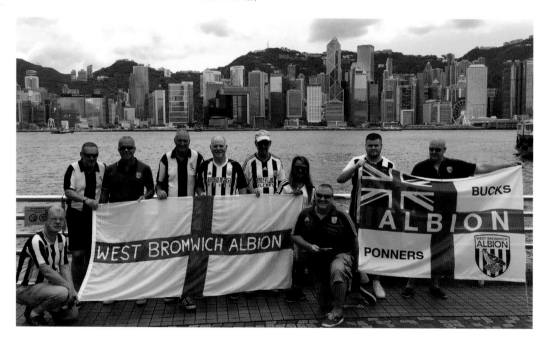

ALBION IN HONG KONG

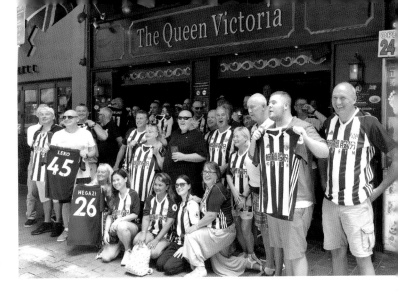

Top right: Our 'local' in Hong Kong: The Queen Victoria.

Middle right: Albion fans were invited to meet the players after a training session.

Bottom left: Parkesy and Boo – the entertainment officers!

Bottom right: Richard Crawley with his well-travelled flag.

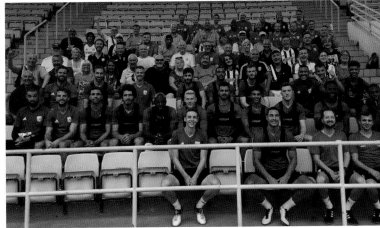

**Crystal Palace
Lost 0-2
Premier League Asia
Trophy 3rd and 4th
Place Play-off
Att: est. 25,000
Hong Kong Stadium
22 July 2017**

In between our two games, the Albion directors, staff and Brendon Batson joined the fans in the Queen Vic for a great afternoon. Chairman John Williams even put his credit card behind the bar, providing a couple of hours of free drinking. A full set of match-issued kit was given out and every Albion fan in the pub received a new shirt – a terrific gesture from the club and much appreciated by the fans. The day got even better when a coach was laid on to take us all to a training session and a meeting with the players. The match itself was a bit of a non-event, the Eagles beating us 2-0 in a fairly even game. Liverpool duly won the tournament and we came home with the wooden spoon!

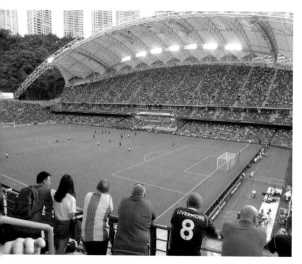

Above left: The magnificent Hong Kong Stadium.

Above right: Norman, Dubsey and Matt James mix with the Crystal Palace fans.

Below left: Dubsey and 'Dog Food' Dave Griffiths being interviewed for Asian TV.

Deportivo La Coruna
Lost 0-2
Trofeo Teresa
Att: 3,960
Estadio Municipal
** de Riazor**
5 August 2017

There was actually a trophy at stake for this friendly. Unfortunately it was fairly obvious that it was not coming our way as soon as Jake Livermore received a straight red card for lashing out after forty minutes. Deportivo went on to stroll a 2-0 victory. The Riazor is a fantastically placed stadium on the Spanish coast. Coruna is not the easiest place to get to; a number of Baggies flew into Porto and chartered a bus from the Portuguese city. After the game, Deportivo's manager and ex-Albion boss Pepe Mel called in at the local pub to say hello to the Albion fans – a nice touch from our popular former gaffer.

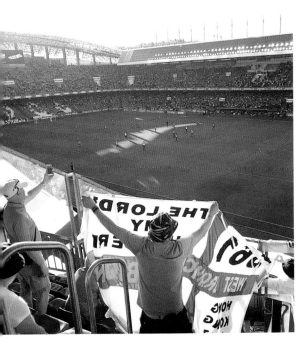

Above left: Inside the Estadio Municipal de Riazor.

Above right: Nick 'Peachy' Peach and 'Time Bomb' Tim Bayliss.

Left: Snarka, Tezza Paul and Barry Swash with former Baggies boss Pepe Mel in the pub after the game.

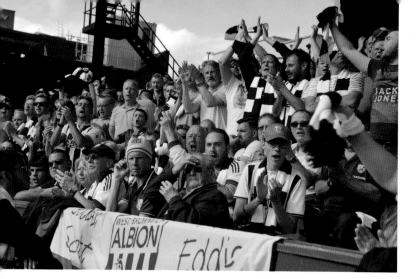

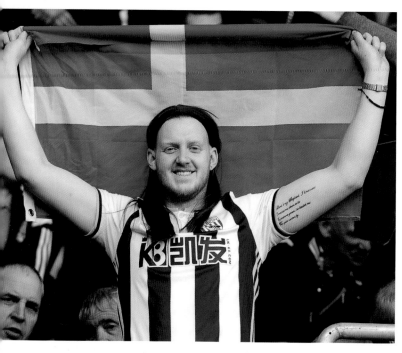

Top: Our new Chinese owners gave every Albion fan a scarf at Crystal Palace for the opening game of the 2016/17 season. It worked: we won 1-0.

Left: Some fans paid tribute to our departed big Swede Jonas Olsson at Swansea for the last game of the 2016/17 season.

Below left: Aussie Baggies Jack and Georgie O'Ryan from Adelaide with Baggie Bird and Albie in the Fanzone.

Below right: Maurizio Abela – better known as Malta Baggie.

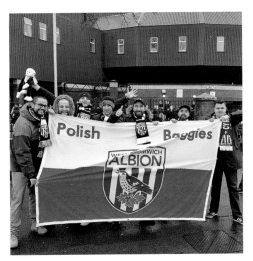

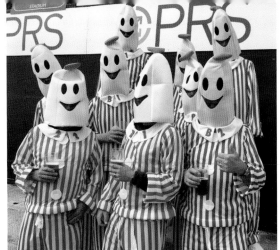

Above left: Polish Baggies at The Hawthorns.

Above right: Baggies in Pyjamas: Albion fans at the Rhyl pre-season game, 2017.

Second from top: Three Baggie Birds – Sarah Rudge, Heidi Turner and Lizzie Hayward – before our game at Brighton. 09.09.17

Second from bottom: The Tipton Albion forty-year reunion. Albion v Watford. 30.09.17

Below left: Albion regulars Tom Lohmas and Gary Ballard.

Below right: The newly formed Albion LGBT group at Wembley before our game against Spurs. 25.11.17

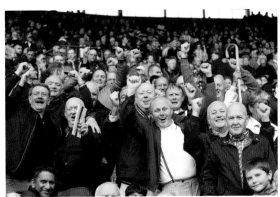

Acknowledgements

Thank you to the following for submitting images and making this book possible. Apologies if your photograph(s) didn't make the final edit – I was absolutely inundated with material:

Helen Allport
Franc Andrews
Ian Atkins
Sarah Atkinson
Graham Baker
Norman Bartlam
Andy Baylis
Tim Bayliss
Neil Beasley
Colin Bradley
Richard Brown
Jennie Caddy
Kevin Candon
Sharon Cartwright
Pete Cashmore
Dave Chapman
Mark Colley
Phil Cooper
Steve Copson
Mick Corfield
Alice Patricia Court
Carl Dellicott
Myra Denton
John Deol
Gemma Downes
Peter Downing
Graham Dring
Jonathan Eden
Neil Edmunds
Ian Edmunds RIP
Gill Evans
Chris Ewing
Steve Fisher
Lee Fletcher
Andrew Freeborn

Doug Grant
Dave Griffiths
Michael Hawkes
Rob Hawkins
Lizzie Hayward
Diane Heggie
Dave Hewitt
Duanne Hill
Duncan Holman
Ian Hopcroft
Glyn Hopkins
Lorraine Howells
Daviid Howson
David Instone
Stewart Jeens
Alan Jones
Tony Jones
Tim Jukes
Jason Kelly
Bob Kettle
Joanne Klein
Dave Knott
Tom Lohmus
John Mangan
Ethel & Bill Mason
Jonathan Mather
Andy Matthews
Tony Matthews
Peter Moore
Roy Morley
Stuart Mowat
Davis O'Ryan
Rob Paddock
David Payne
Paul Piddock

Barrie Plant
Mark Ralphs
Nathan Reynolds
Neil Reynolds
Steve Sant
Ian Smallman
Barry Swash
David Taylor
Chris Thompson
Ian Tinsley
John Tkaczuk
Kev Wallace
Andy Ward
Chris Ward
Garry Whitehouse
Matthew Whitehouse
Mark Whitehouse
Susan Whiteley
Marilyn Wilkes
Graham Winder
Nigel Woodhall
Glynis Wright
Matt Wright
Simon Wright
Piero Zizzi

Special thanks to Pete's Picture Palace, the Regis family, Laurie Rampling, Kevin Grice, Express and Star, Trinity Mirror, Rex Features and West Bromwich Albion Football Club.